.

IMAGES
of America

IRISH IN YOUNGSTOWN
AND THE GREATER MAHONING VALLEY

The watershed of the Mahoning River forms the Greater Mahoning Valley. It influenced the pattern of late eighteenth- and early nineteenth-century Euro-American settlement in the region, blurring modern day state boundaries. The name Mahoning is derived from the Native American word "mahonik," meaning "salt lick." Pioneers formed settlements near important salt deposits, and these soon grew into towns such as Niles, Newton Falls, and others. Following established patterns, Irish immigration into the region spread widely across today's Trumbull, Mahoning, and Columbiana Counties of Ohio and Mercer County of Pennsylvania.

(cover) "Oh! Me name is MacNamara, I'm the leader of the band. Although we're few in numbers, we're the finest in the land. Oh! I wear a bunch of shamrocks and a uniform of green . . ." On the 17th of March, St. Patrick's celebrations are enjoyed by people of countless nationalities in homes, schools, organizations, and at parades and parties. Bandleader Sally Phipps and the 1948 third-grade class of St. Patrick's School are enthusiastic for the grand event! "A credit to old Ireland is MacNamaras's band." (Courtesy of Sally Phipps Perunko.)

IMAGES
of *America*

IRISH IN YOUNGSTOWN
AND THE GREATER MAHONING VALLEY

The Irish American Archival Society
Book Committee:
Sally Murphy Pallante
Scottie Hanahan
Jim Dunn
Ted Miller
Martin Pallante
Terry Dunn

Edited by L. Diane Barnes

ARCADIA
PUBLISHING

Published by Arcadia Publishing
Charleston, South Carolina

Library of Congress Catalog Card Number: 2003116586

For all general information contact Arcadia Publishing at:
Telephone 843-853-2070
Fax 843-853-0044
E-mail sales@arcadiapublishing.com
For customer service and orders:
Toll-Free 1-888-313-2665

Visit us on the Internet at www.arcadiapublishing.com

This work is dedicated to our Irish ancestors.
Deep peace of the smiling stars to you.
Deep peace of the quiet earth to you.
Deep peace of the Son of Peace to you.
Until we meet again,
May God hold you in the hollow of His hand.
—from old Gaelic prayers

(Image reproduced by permission, American
Greetings Corporation©, AGC, Inc.)

CONTENTS

ACKNOWLEDGMENTS

The Irish-American Archival Society (IAAS) is indebted to many individuals and organizations for help in the process of gathering images and information for this book. A generous donation from the Irish American Foundation assisted in funding this volume. The Foundation officers recognized the potential of the book as an enduring chronicle of the Irish in the Mahoning Valley and seized the opportunity to cooperate in pursuit of this historic endeavor. A grant from the International Institute Foundation of Youngstown, Inc. provided financial support. The finest editor any authors ever had, L. Diane Barnes Ph.D., specialist in nineteenth-century United States and Ohio history, worked tirelessly to ensure the accuracy and completeness of the work. In the final analysis, Doctor Barnes was as much an author as an editor. We are especially grateful to Mahoning Valley Historical Society (MVHS) director, H. William Lawson, and to archivist Pamela Speis, who spent hours of her time with us during the image selection process, as many of the images originated in the collection of the MVHS. Author and Youngstown native, Juilene Osborne McKnight, wrote a special foreword for this volume, and Chuck Klingensmith of the Photo Place ably turned our photos into electronic images. Historians and area specialists reviewed our material and helped with fact checking, including Donna DeBlasio, who attended many meetings and offered moral support to our editor. We are also indebted to the expertise of T.E. Leary, Thomas Carney, Paul McBride, Cathy Rodabaugh, Nancy Yuhasz, and Brian Corbin. Special information was provided by Bob Casey, Robert Calcagni, Anne M. Colucci, Wallace Dunne, Eleanor Carney, Mary El'Hatton, Mary Eddy Gillen, Vincent Gilmartin, Mary Catherine Gribbon, Mark Hanahan, Carmen Leone, John Manning, Father Edward Noga, John Pallante, William Pallante, Scott Schulick, and Tom Poole. Members of the IAAS book committee and chapter authors Jim Dunn, Terry Dunn, Scottie Hanahan, Ted Miller, Martin D. Pallante, and Sally Murphy Pallante are to be commended for their persistence in seeing this project to completion. A special thank you goes to Arcadia editor Melissa Basilone, who ably guided this project to publication.

FOREWORD

We are the **Irish**.

We are the children of artists.

They were the traders of ancient Europe, weavers in silver and gold. All their knotwork had a message; life braids itself into life. Eternal. They wore braided jewelry and embroidered plaid, a moving riot of color and beauty. The Irish love of physical adornment is an ancient Celtic ancestral trait.

We are the children of warriors.

Caesar called them the Gauls. They went into battle unfettered, some with their hair on fire, men and women side by side. Before the fierce warriors, the wild women of the Celts, the Romans broke ranks and fled. Our powerful Irish women, our fighting Irish men hail straight from our Celtic ancestors.

Caesar feared their very lack of fear.

What frightens you? he asked them.

We fear that the sea will rise up and swallow us; we fear that the sky will fall in upon us.

And *what of death?* he asked them.

We are the Celts, they answered. *For us there is no death.*

We are the **Irish**.

We are people of the word.

All of our warriors were also poets. CuChulainn and Fionn, warriors who wove with words and sword. So important were words to our ancestors that to be a warrior, each applicant had to pass the test of poetry—to memorize the verses twelve times twelve. To be a warrior in the ancient Celtic world was to live by a strict code of honor and to carry the power of words. So important were words to our ancestors that a poet could simply say the word and battle would cease. Our modern poets and politicians and playwrights come honestly to their ancestral love of words.

We are the **Irish**.

We are people of Faith.

Throughout history each time a conqueror tried to take faith from us, we simply moved it to the fields and the forests, hid it from invaders, and would not let it go.

We are the children of hunger.

Driven from our ancestral lands, pressed by the Famine we wandered the world: Canada, Australia, New Zealand, America. We remember that hollow in the belly. It made us hungry for education, for security. Everywhere we went we were willing to use all of our ancestral skills—our ability to fight for each other and work hard, our artistic skills, our uncanny knack for words, our unceasing faith. We number among the largest and most successful sub-ethnic groups in the United States. But the memory of hunger also made us generous. The Irish are known for the need to feed: themselves, their families, the hungry world.

We see ourselves here in this book as the American Irish, but in all of these Mahoning Valley immigrants dwell the ancient Celts, a people in love with art, music, words, but unafraid to fight for family, for faith, and for justice.

Fearless. Artistic. Faithful. Eternal.

We are the **Irish**.

–Courtesy of author Juilene Osborne McKnight

An elaborately carved stone that dates back more than 5,000 years stands at the entrance of the prehistoric monument at Newgrange, near the River Boyne in County Meath, Ireland. For the ancient Irish Celts, the spiraling knotwork on the stone had the religious meaning that life braids itself eternally into life. It was believed that there is a point at the center of the spiral where heaven and earth are joined. The authors view this ancient symbol as a link to ancestors to whom this book is dedicated.

One

THE EARLY YEARS

The first Irish to reach the Mahoning Valley were Ulster Irish, who arrived in the late eighteenth and early nineteenth centuries. Many first settled in Pennsylvania and then migrated into the Valley looking for economic opportunity. The earliest known permanent Irish presence is attributed to immigrant Daniel Shehy, who accompanied New Yorker John Young in 1796 on an expedition to examine a 25-square-mile section of land he was about to purchase from the Connecticut Land Company. Young did not remain, but Shehy bought 1,000 acres and along with his wife, Jane McLain Shehy, joined a small group of pioneers who formed Youngstown.

Irish immigration to America accelerated in the nineteenth century and peaked in the crisis surrounding the Potato Famine years, 1845–49. Failure of the staple food crop for several consecutive years resulted in the deaths of some one million, and the impoverishment of three million more. The ensuing crisis forced many to flee Ireland for the "New World." In the United States, the exodus from the Emerald Isle coincided with the impulse toward industrialization. Strong Irish workers were welcome on American public works and internal improvement projects such as canals, waterworks, and railroads. By 1850, as the population of the Mahoning Valley topped 121,000, foreign-born men and women already numbered eight percent. Irish men and women arrived in patterns of chain migration, following family and friends to the Mahoning Valley. Unlike other European ethnic groups, it was not unusual for unmarried women to migrate on their own, often seeking employment as domestics in the homes of well-to-do businessmen and merchants. Thus, while the normal pattern of migration meant families followed once the father or husband found work, for the Irish it was just as likely that unmarried brothers followed unmarried sisters to America.

Once in the Mahoning Valley, Irish men helped build and maintain the Pennsylvania and Ohio Canal, the Cleveland and Mahoning Railroad, and were among some of the region's earliest skilled iron workers. The Mahoning Valley Irish quickly adapted to their new country, with many serving bravely in Ohio regiments during the Civil War, including Limerick-born tailor, James Collins, who proudly served in the Union army and then returned to Youngstown after being wounded during the 1864 Battle of the Wilderness.

Although there was a strong Irish presence in the Mahoning Valley by 1860, the largest number of immigrants arrived in the period following the Civil War. In 1900, the federal census for the counties comprising the Mahoning Valley counted 5,413 men and women born in Ireland. By that date, the Valley Irish community was well established, and many were second and third generation Americans.

James, John, and Patrick Kennedy arrived in Youngstown, Ohio, in 1855 after leaving their native County Tipperary, Ireland. In the Mahoning Valley, the Kennedy's prospered in the construction business and invested their money in a variety of local projects. Their descendants remain in the region where today some are bankers, educators, spiritual advisors, and physicians. In many ways, the Kennedy family illustrates the success of Irish Americans in the Mahoning Valley counties of Columbiana, Mahoning, and Trumbull in Ohio and Mercer County, Pennsylvania. As one of the earliest Euro-American groups in the region, they quickly assimilated and moved into established positions in business, industry, and local governance and comprised a strong presence in the Roman Catholic Church and parochial education.

Now in the early years of the twenty-first century, the descendants of Irish immigrants comprise approximately 15 percent of the Mahoning Valley's population. Irish heritage is proudly displayed across the Valley at area St. Patrick's Day parades and celebrations and is preserved in organizations such as the Ancient Order of Hibernians (AOH) and the Gaelic Society.

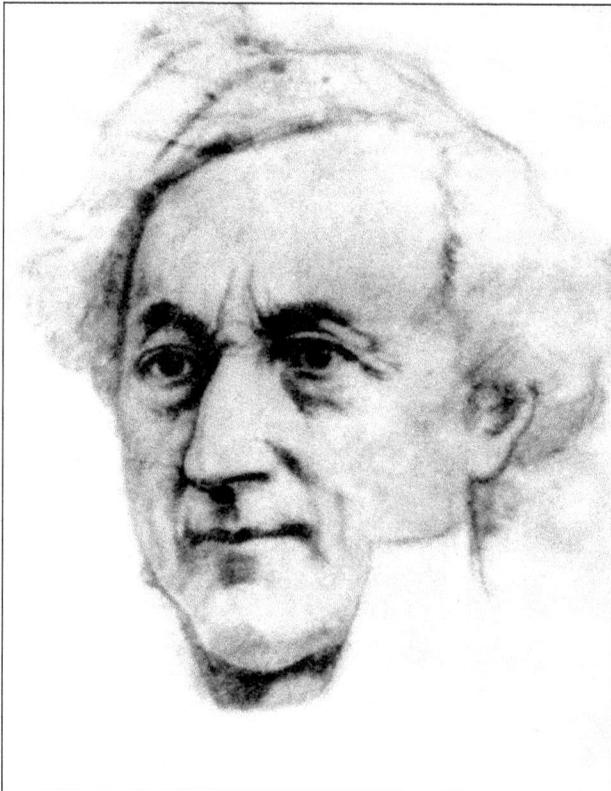

John Young, pictured here, surveyed and established the boundaries for the city of Youngstown, Ohio. Daniel Shehy accompanied Young on this trip and remained to establish the first Irish presence in the Mahoning Valley. (Courtesy of MVHS.)

These early nineteenth-century portraits depict Jane McLean Shehy, wife of Daniel Sr., their son Daniel Jr., and his wife Charlotte Pearson Shehy. Jane married Daniel, an Irish emigrant from County Tipperary, in 1798. She was a true pioneer woman who made a home for Daniel and their nine children in the unsettled wilderness of the Western Reserve. Daniel Jr. provided in his will that a portion of his estate become a trust for the education of the poor children of Youngstown. (Courtesy of MVHS.)

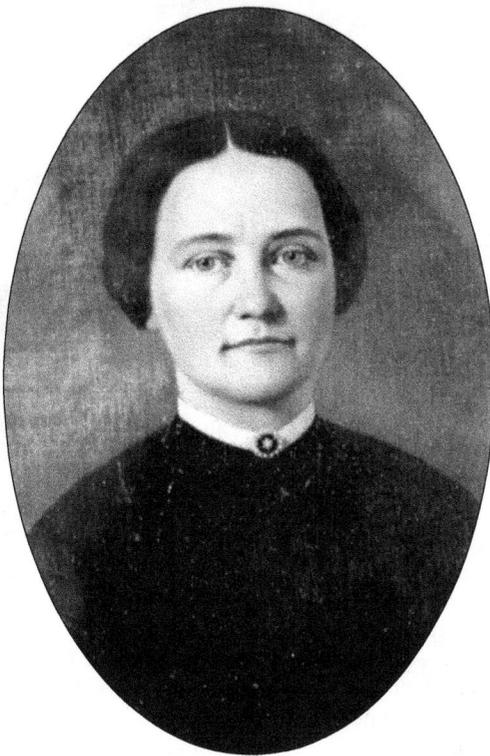

11

In 1796, the founder of Youngstown, John Young, met pioneers Colonel James Hillman and Isaac and Abraham Powers for the first time at a site along the Mahoning River in an area now known as Spring Common near downtown Youngstown. While Young never lived in the settlement that bears his name, Hillman, Powers, and another early settler, Daniel Shehy, stayed and helped to build a new community. These men, some of whom were of Irish extraction, were the first of their ethnic group to make their homes in Youngstown. In the first few decades of the nineteenth century, the Village of Youngstown grew slowly, but by the Civil War, a burgeoning iron industry attracted settlers to the area. The early twentieth century, however, saw the Mahoning Valley grow at an even more rapid pace with the complementary expansion of its signature industry of steel manufacture. By the mid-1920s, there were three major steel companies in Youngstown: the Youngstown Sheet and Tube Company (with the Campbell Works and the Brier Hill Works), the Ohio Works of Carnegie Steel (U.S. Steel), and the Republic Iron and Steel Company. To support this huge industry came thousands of people, and Youngstown's population soared from 45,000 in 1900 to its all-time high of 170,000

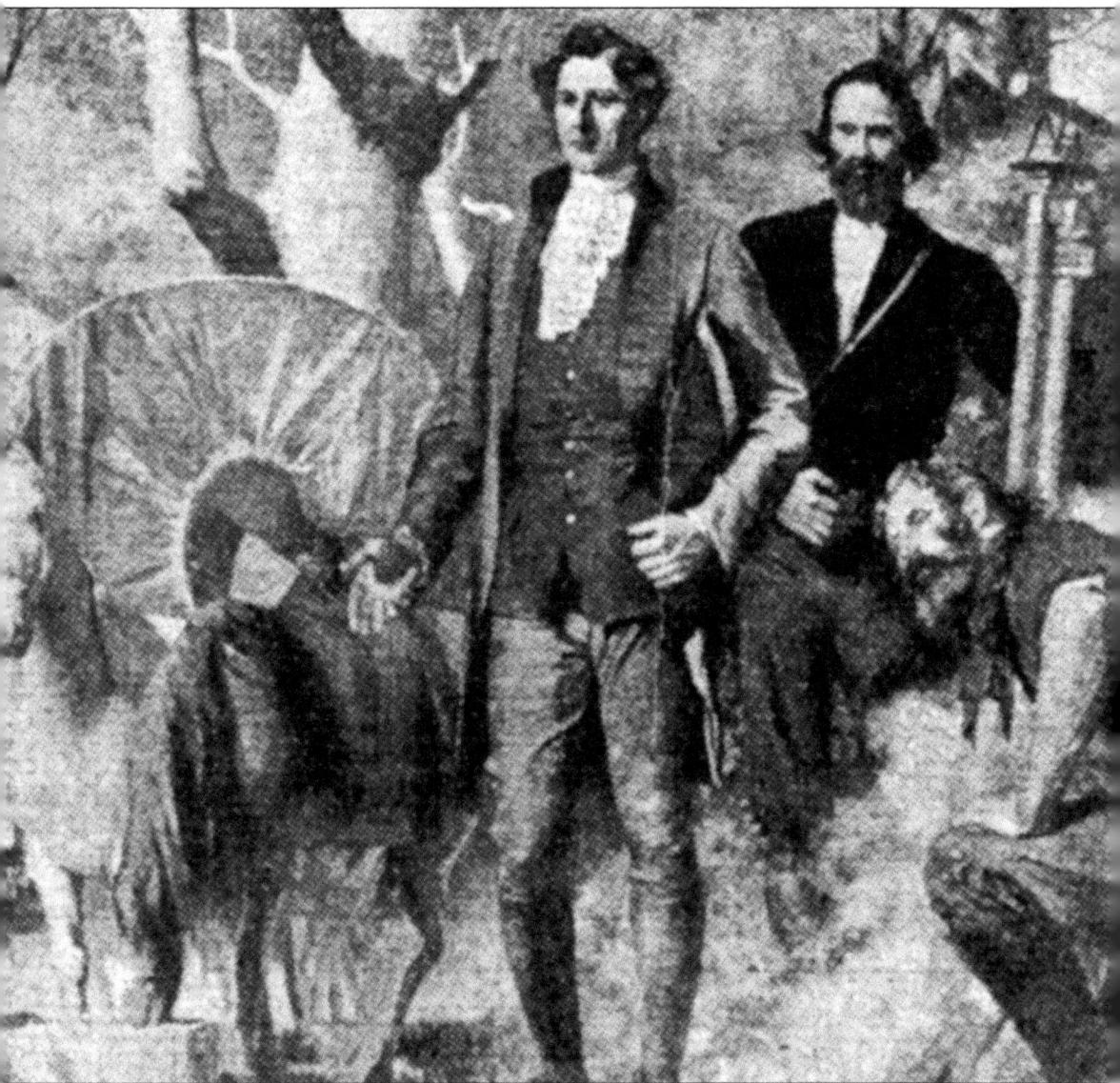

by 1930. Many of the people who came to the Mahoning Valley seeking jobs in the iron and steel industry were originally from Ireland or were the children of Irish immigrants. Along with emigrants from around the world, as well as migrants from within the United States, the Irish contributed to the rich ethnic diversity that characterizes Youngstown and the Mahoning Valley. The mural *The Beginning of Youngstown*, seen here, depicts the first meeting between Young and the Powers brothers. Artist A.E. Foringer of Greenwood, New Jersey, created the mural, which is in the lobby of the Home Savings and Loan Building in downtown Youngstown. One of Youngstown's foremost architects, Charles F. Owsley, designed the Colonial Revival headquarters for the Home Savings and Loan Company in 1919. The Home Savings and Loan, which is still a Youngstown institution, began as the Home Building and Loan Company in 1889. The bank was originally located on the Central Square, before moving into the current ten-story landmark building. Its elegant clock tower is brightly lighted at night, giving a distinctive look to the Youngstown skyline. (Courtesy of the *Vindicator* Printing Company, Archives Division and MVHS.)

Irish immigrants formed an important part of the workforce that built the Pennsylvania and Ohio Canal, beginning in 1838. Operational by 1839, the canal connected Youngstown with Pennsylvania and contributed to the city's population growth and economic prosperity. The Irish immigrants who worked on the Ohio canals received 30¢ a day, food, whiskey, and a shanty. The canal system was called "the Irish graveyard," for many workers suffered from malaria, and it was said there was "a dead Irishman for every mile of canal." (Courtesy of MVHS.)

Irish laborers not only labored to dig canals, but also constructed the locks that elevated and lowered water levels to allow flat-bottomed canal boats to navigate through the waterway. The Pennsylvania and Ohio Canal closed in 1877, and today the ruins of locks, such as this one, are the only remaining evidence of the Canal Era. (Courtesy of MVHS.)

14

Long trainloads of Irish immigrants arrived in Youngstown by rail—some likely on these tracks at the B&O and Erie Railway Stations. Typically, most journeyed west to join a family member who had come earlier to the Valley to work in the new steel mills. A typical scenario would be for the first arrival to send a letter back to Ireland with the cost of a steamship ticket and a railroad ticket.

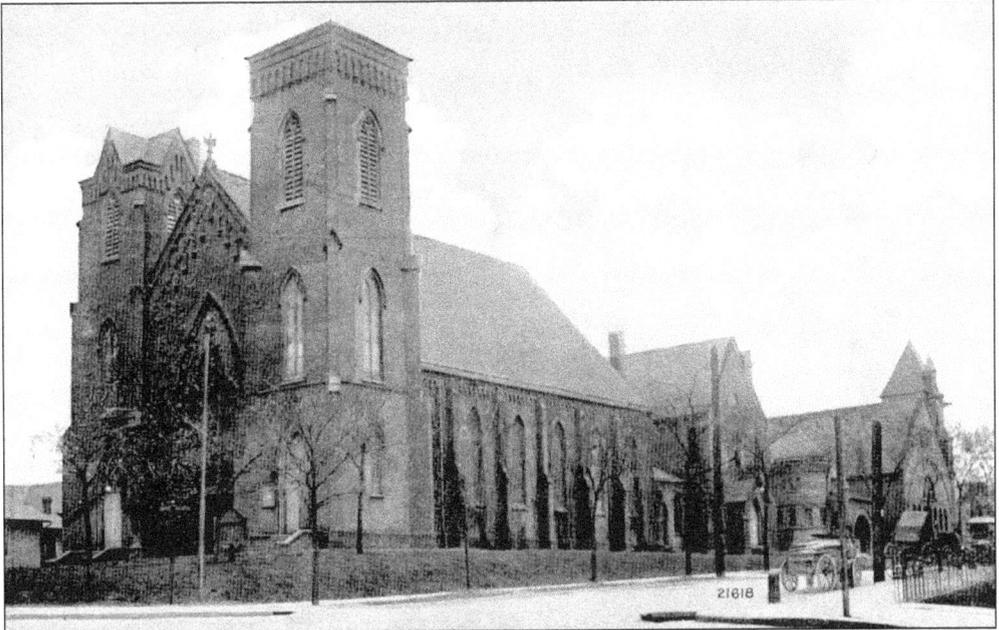

The First Presbyterian Church of Youngstown, the oldest church in the Western Reserve, was founded in 1799 to serve the spiritual needs of early Ulster Irish settlers. The first pastor, Reverend William Wick, was one of the Valley's early pioneer leaders. The current church at the corner of Wick Avenue and Wood Street is the third to serve the assembly.

This painting by an unknown artist is titled *The Isaac Powers Farm*. It offers a vision of the early Mahoning Valley farm of a pioneer Irish-American family. The Powers homestead stood on a promontory above trolley car stop seven on Poland Avenue, overlooking the valley below. (*The Isaac Powers Farm*, unknown, the Butler Institute of American Art, Youngstown, Ohio.)

Taken in County Tipperary, Ireland, in the late 1840s, this image shows Kennedy brothers James, John, and Patrick with an unidentified friend. The Kennedy's arrived in Youngstown in 1855, where the family prospered in business ventures across the Mahoning Valley. John and Patrick formed a company that constructed many Youngstown streets using blast furnace slag. The pair were also shareholders in the Excelsior Building downtown. Family descendants in the Valley include two physicians, two priests, and two teachers. Descendant Isabelle Turner Kennedy founded the Kennedy School for Gifted Children on Broadway Avenue. (Courtesy of John Kennedy and Peggy Kennedy Yanek.)

The ancestors of Joseph G. Butler Jr. came to America in 1759 from the Dublin vicinity. Butler made significant contributions to the steel industry nationally and in the Mahoning Valley. He created the Butler Institute of American Art and spearheaded the incorporation of the Mahoning Valley Historical Society (MVHS). He built the McKinley Memorial in honor of his close childhood friend, U.S. President William McKinley. Butler's three-volume history of the Mahoning Valley, *Youngstown and the Mahoning Valley, Ohio*, remains a standard reference for scholars of the Western Reserve.

Founded in 1919, the Butler Institute of American Art is the first structure in the United States built to specifically house a collection of American art. The famous New York architectural firm of McKim, Mead, and White designed the museum that was Joseph Butler's gift to the people of his hometown. (Courtesy of Sally Murphy Pallante.)

The "schoolmaster of the nation," William Holmes McGuffey was of Irish and Ulster Irish descent, with his maternal grandmother coming from Donegal, Ireland. Author of the famous *McGuffey Eclectic Reader*, which was first published in 1836, he provided instruction in reading, writing, ethics, and religion. A statue in McGuffey's memory stands at Ohio University in Athens, Ohio, where he served as the school's fourth president. There is also McGuffey Hall at the University of Virginia, where he served as professor of philosophy. Henry Ford, himself a man of Irish stock, so admired McGuffey that he established the McGuffey Museum as a tribute to the respected educator. His books for young readers stressed honesty, hard work, and moral living. He encouraged students to live their lives serving others and to always show consideration to people and animals. The *McGuffey Eclectic Reader* greatly influenced the shaping of the mid-nineteenth-century American mind. The readers have never been out of print and are considered by many to be crucial components of American cultural history. (Courtesy of the Butler Institute of American Art, Youngstown, Ohio, and Helen Owen.)

The 1911 groundbreaking for St. Elizabeth Health Care Center's first permanent structure is seen here. Joseph G. Butler chaired the fund raising campaign, which included Aviation Day, which brought the first airplane to Youngstown. St. Elizabeth's received its first patient December 8, 1911, and continues to serve the Mahoning Valley.

In 1976, the architectural firm of Hanahan and Strollo designed a new south wing for St. Elizabeth's Health Care Center. The installation of the cross is seen here.

Under the direction of Bishop John P. Farrelly of the Cleveland Diocese in 1911, Sister Genevieve Downey H.H.M. became the first administrator of St. Elizabeth's Health Care Center. At that time, the Sisters of the Holy Humility of Mary who she employed to minister to the sick received a stipend of $25 per month. (Courtesy of MVHS.)

(*left*) Dr. William J. Whelan, born in Ireland, was the first Irish physician to practice in Mahoning County, where he organized the Mahoning County Medical Society and helped found the Youngstown City Hospital.
(*right*) His son, Dr. Raymond E. Whelan, was a driving force behind the establishment of St. Elizabeth's Hospital and was its chief of staff. His grandson is Father Richard Murphy of the Youngstown Diocese. (Courtesy of Father Richard Murphy.)

By the late nineteenth century, Irish Americans moved into important roles in the community, including government and the protective services. Second generation Irish men dominated the police and fire departments of many American cities, including Youngstown. These portraits show the mustachioed image of Police Officer Gallagher and Police Officer Carney, both of the Youngstown Police Department. (Courtesy of MVHS.)

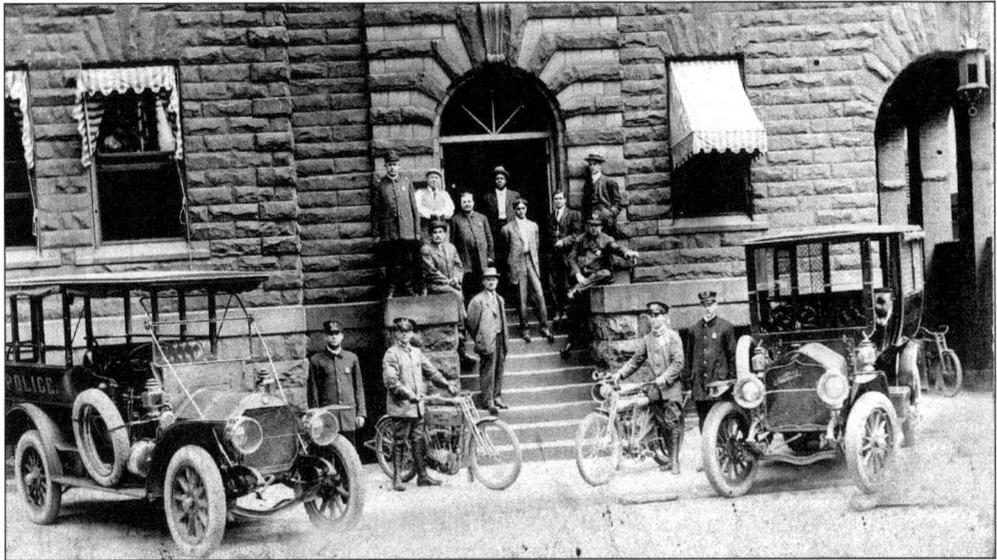

The Central Police Station was the professional home of many of loyal sons of Erin who served the city in the early years. A few of the names excerpted from an early roster include: Michael Gallagher, John J. McDonough, James J. O'Connor, Patrick J. Kinney, William J. Burke, Martin Farragher, James Ryan, P.D. Foley, and James Donlin. (Courtesy of MVHS.)

This 1910 photograph of the Central Fire Station at the intersection of Boardman and Hazel Streets shows a group of the city's finest firefighters, including many Irish with their state-of-the-art equipment. The Governor Tod Engine House on Hazel Street also served Youngstown when it was still a village. (Courtesy of MVHS and *History of the Youngstown Fire Department— Past and Present.*)

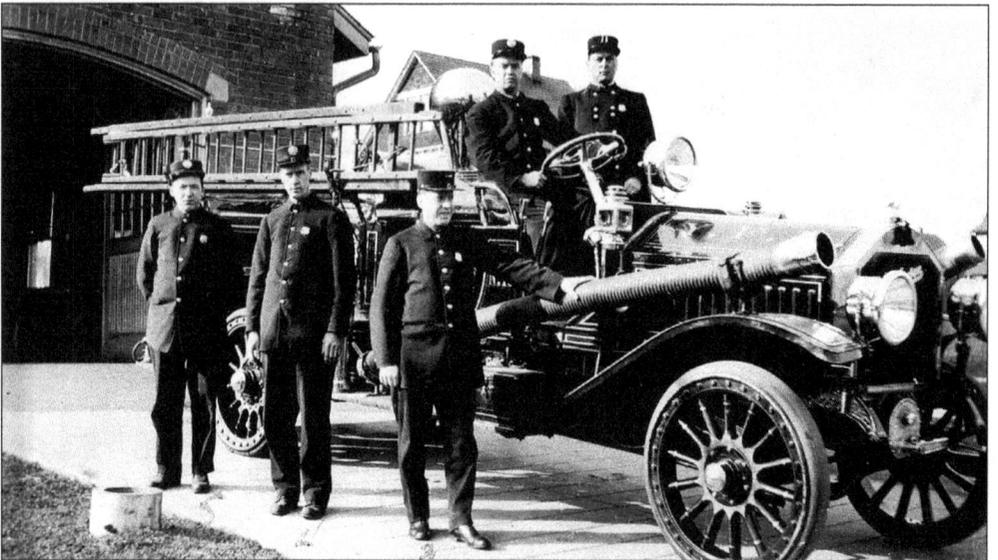

Youngstown firemen John Flynn, John Price, James Mahon, Charles Young, and Captain William Bailey of Station No. 10 proudly pose with the department's ladder truck. Motorized fire equipment replaced horse drawn trucks and steam engines as the Youngstown Fire Department adapted to modern technology. This station was located at the intersection of Mahoning and Eleanor Avenues near downtown. (Courtesy of MVHS and *History of the Youngstown Fire Department.*)

22

Anna Smiley was born in Connacht, Ireland, in 1821. She married Thomas McNamara and fled with him to Durham, England, during the early years of the Famine. They worked as servants at Sulgrave Manor, the ancestral home of George Washington, and raised three children: Harry, Anna, and Jane. Anna's brother, Captain Jack Smiley, was a sailor who settled in Sharpsville, Pennsylvania. The family eventually settled in Mercer County, Pennsylvania. Anna died on May 12, 1873, from complications of asthma. (Courtesy of Ted Miller.)

Peter Walsh was born in Tullamore, County Offaly, in 1832, to parents Michael and Mary Gilligan Walsh. Family tradition suggests Walsh immigrated to Scotland before he came to Youngstown as a lad. He married Margaret Hoey and lived at Powers Hill in the1860s. Fourteen of the couple's 22 children lived to maturity, including their first, Thomas Charles. The Walsh family lived in this home at 1001 State Street, Youngstown. (Courtesy of Eileen Walsh Novotny.)

Erected in 1870, the Civil War monument on Youngstown's Public Square commemorates the men from Youngstown who gave their lives for the Union. The names of the fallen soldiers and the battles where they died are inscribed around the base of the monument. The soldier at the top represents the valiant heroes of the 105th Ohio Volunteer Infantry regiment in which many Irish-American young men served and died for their adopted country. The inscription on the monument reads: "Erected by the citizens of Youngstown, in memory of the Heroes of the township who gave their lives to their country in the War of the Rebellion, 1861 to 1865." (Courtesy of Sally Murphy Pallante.)

Chartered as a place to welcome Union Civil War veterans, especially members of the Grand Army of the Republic, the Tod Post was named in honor of Youngstown native, David Tod. Besides being a leading iron master, Tod served as Ohio's governor during the Civil War. Pictured is an unknown Tod Post member, a proud symbol of the scores of local veterans, including James Brannon, Dennis McKenna, John McBride, William Whelan M.D., John Galvin, John Loney, Richard Giblin, Thomas Lally, Michael Thomas Murphy, John McGinnis, and Pat Donlin, who served with great bravery and honor. (Courtesy of MVHS.)

James Collins, born in Limerick in 1831, was a decorated Civil War veteran. He was among many injured during the May 1864 Battle of the Wilderness. Collins' diary recounts his experience of lying wounded on the battlefield, and of his wife, Anne McDermot Collins, meeting President Lincoln while visiting him at a Washington hospital in the aftermath of the battle. Collins was the great grandfather of Marie Barrett Marsh of Warren, Ohio. (Courtesy of John Marsh.)

During the Civil War, Irish Americans served in Ohio Union Army regiments that won fame at the Battles of Rich Mountain, Murfreesboro, Chickamauga, Antietam, and Shiloh. This painting depicts future University of Notre Dame president, Father William Corby, offering a blessing and general absolution to the Irish Brigade at Gettysburg on July 2, 1863. Eighty-nine of the 144,000 Irish-born men in the Union Army received the Congressional Medal of Honor. A total of 210 Irish-born men have received the medal—the largest group of immigrants to receive the honor. (Copyright Bradley Schmehl.)

Michael McGovern, the "Puddler Poet," emigrated to the United States from Castlerea, Roscommon, Ireland, in 1848 at the height of the Famine crisis. Like many refugees, McGovern first immigrated to London, and there he met and married Anne Murphy. The young couple decided that they could find work and hope for a better future in America. They eventually came to Youngstown where McGovern found work as a puddler in the rolling mills. Puddlers were highly skilled iron workers who labored in heat and smoke and stirred molten iron, which was then shaped and rolled into ingots. While McGovern stirred the iron, he also stirred his thoughts and impressions, gathering the words to be molded into the poetry for which he is best remembered. As the McGovern family settled into permanent life in the Mahoning Valley, his poems became numerous. McGovern wrote about the mills, the laborers, Ireland, love, and the injustices imposed upon the working class. His writings appeared in many newspapers and Irish-American periodicals. His book of poetry, *Labor Lyrics*, appeared in 1899 and received acclaim throughout the United States. He was a member of the Emmett Literary Society, the Ancient Order of Hibernians (AOH), and the Amalgamated Association of Iron and Steel and Tin Workers. McGovern's own words are his epitaph:

Just place a rock right over me,
And chisel there that all may know it.
Here lies the bones of M. McG whom people called
'The Puddler Poet.'

(Courtesy of MVHS.)

Two

BUSINESS, INDUSTRY, AND LABOR

During the early years of the twentieth century, Youngstown and the Mahoning Valley became the second largest steel-producing region in the United States. Even before the steel mills became a prominent Valley industry, coal mines and coke plants provided employment that increased population. Many established Irish businesses prospered, and new immigrants followed kin to the Valley and employment opportunities. Irish businessmen took advantage of the boom in coal production, including Thomas C. Walsh, who operated a slant coal mine on a farm east of Youngstown's Wick Avenue. During the peak of coal production in the 1870s, Irish men were strongly represented among the 3,500 miners in the region.

By the time that the iron and steel industry came to dominate the Valley economy, many of the region's Irish were second and sometimes third generation Americans. The early immigration of the Irish put them in a strong position to move up the ladder ahead of less skilled immigrants arriving from eastern and southern Europe in the late nineteenth and early twentieth centuries. Their assimilation into American culture allowed them to move into positions of skill in the mills and to own their own businesses. An early image depicting skilled iron puddlers from the Brown, Bonnell, and Company mill, for example, includes 11 men of Irish descent. Immigrants Patrick, James, John, and Paul Meehan formed the Meehan Boiler Company in the late 1800s and remained active in steel construction until after World War II.

Irish-American Valley residents also prospered in the carrying trade and retail establishments. Second generation Irish-American J.V. McNicholas formed the J.V. McNicholas Transfer Company in 1917, and Richard Gilmartin began a similar transfer company as a drayman using a horse and cart. McNicholas' transfer company is still hauling goods in the first decade of the twenty-first century. The department store of G.M. McKelvey and Company was a familiar landmark in downtown Youngstown for decades, and a descendant of the original store owner is Youngstown's mayor in 2004.

Several Irish families entered the oil or gas business, including the Lyden Oil Company founded in 1919 and the Vahey Oil Company founded in 1893. The A.P. O'Horo Company was completing construction jobs in the Valley as early as 1913 and is still one of the largest contracting firms in the region. Hynes Industries components are shipped throughout the United States. Not to be outdone by their male counterparts, the Irish-American women of the Small family formed the Small Insurance Agency, a highly successful firm that provided for the insurance needs of many Valley residents.

Mahoning Valley Irish-Americans have also been strong activists in the labor movement. Irishman John J. Buckley was active in the Amalgamated Iron, Steel, and Tin Workers union at the national level, as was Michael McGovern. James P. Griffith led Youngstown's District 26 of the United Steel Workers of America and was also active at the national level. Many workers at the area Delphi and General Motors plants are of Irish descent, and the United Auto Workers regularly demonstrate their Irish pride during regional St. Patrick's Day parades and events.

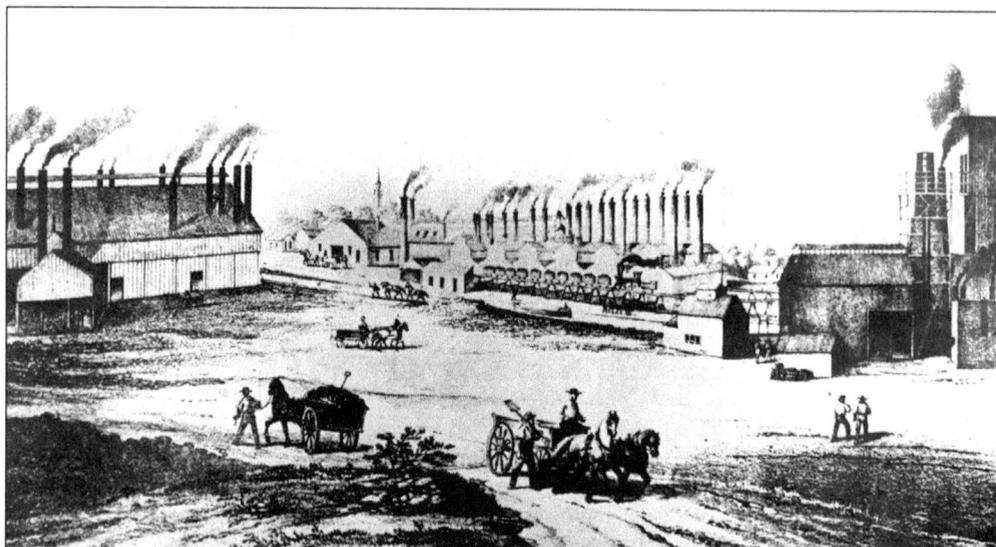

This engraving shows the Brown, Bonnell, and Company mills, which was established in 1855 when a group of iron workers from Pennsylvania bought the Youngstown Rolling Mill. Visible are a blast furnace, puddling furnaces, and the rolling mills. In 1879, Brown, Bonnell, and Company was sold to a group of industrialists headed by Herbert C. Ayer of New York. In 1899, Republic Iron and Steel Company purchased the plant and absorbed it into the larger organization. (Courtesy of MVHS.)

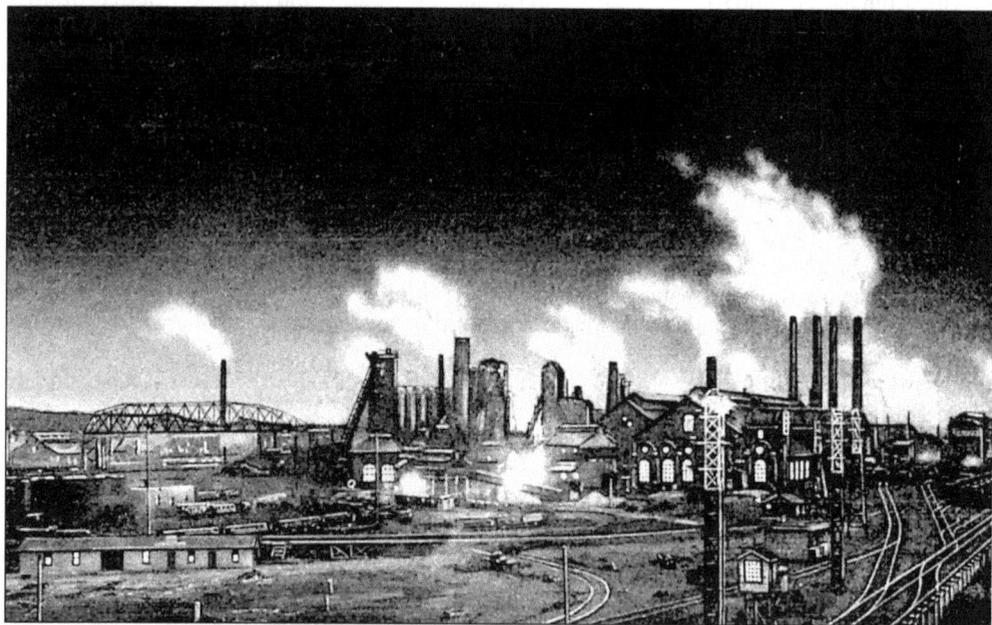

This postcard shows an early twentieth-century view of the Youngstown Works of the Carnegie-Illinois Steel Company, which was a division of U.S. Steel. Many steel and iron workers, including Irish Americans, were attracted to the region for the employment opportunities available.

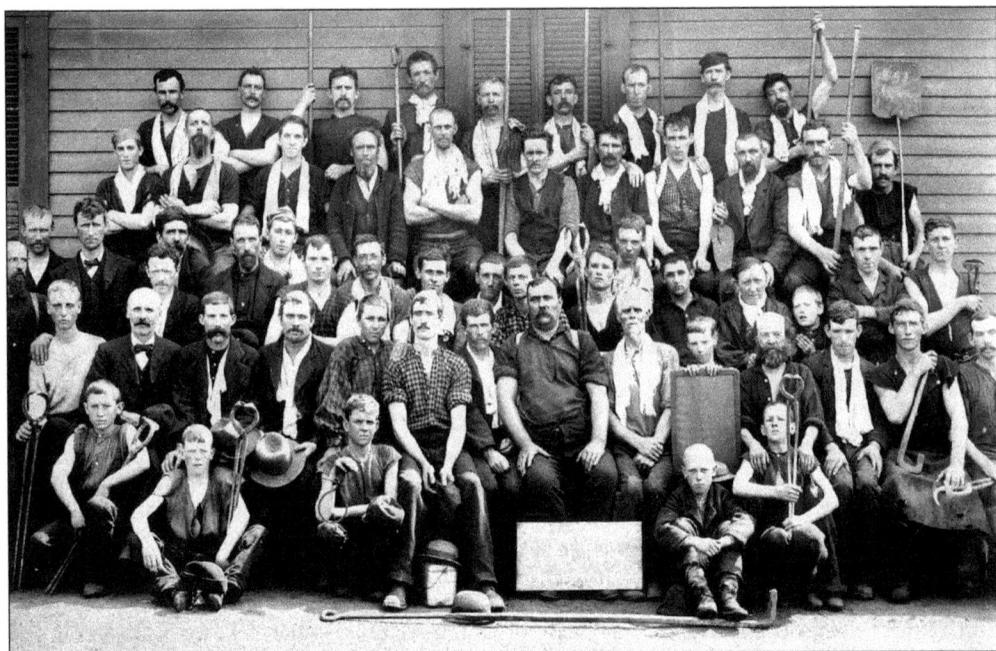

Among these Brown, Bonnell, and Company iron puddlers are 11 Irish men. Contrary to the stereotype of the Irish being relegated to manual labor, 20 percent of the 240 Irish wage earners held skilled positions in Youngstown's 1860 census. In addition to the puddlers, one Irish man toiled as a roller—the top mill classification. Other Irish tradesmen included carpenters, brick layers, shoemakers, teamsters, stone masons, machinists, and plasterers. Irish professional wage earners included engineers and one physician. (Courtesy of MVHS.)

The village of Leetonia is named after William Lee, born in Ireland in 1824. Lee led the group that developed the Leetonia Iron and Coal Company and laid out the village that grew around it. The company was founded in 1865 and eventually operated 200 coke ovens, transforming coal into high-grade fuel for its blast furnaces. By 1879, successor company Cherry Valley Iron and Coal Company employed more than 1,000 workers. This photograph taken in 1896 shows recently quenched coke being loaded into carts for transport to the blast furnaces. This site is now listed on the national historic register. (Courtesy of Linda Lutz.)

Second generation Irish immigrants also contributed significantly to the growth of industry in the Valley. This "slant" coal mine was operated in Youngstown by Thomas C. Walsh from 1895 to 1910. He was the son of Irish Immigrant Peter Walsh. Walsh entered into a lease agreement with John Wick that allowed him to mine coal under farm land east of Wick Avenue, providing he did no damage to the land except for building a mine entrance in a hollow at the extreme north line of the property. The men in the photograph are unknown except for T.C. Walsh, the man with his hand on his hip. (Courtesy of Eileen Walsh Novotny.)

The Meehan Boiler Company organized in 1897 in Lowellville. The company rapidly became an industry leader, active in all kinds of steel construction. To reflect the scope of its activities, the name was changed to the Meehan Boiler and Construction Company. Founders were Irish immigrants Patrick Meehan, James Meehan, Paul Meehan, and John Meehan, along with Robert Gray. Shown here is a preferred stock certificate issued to company secretary James Meehan Jr. in 1914. The company remained active in Lowellville until after World War II. (Courtesy of William Meehan.)

This is the J.V. McNicholas Transfer Company's truck fleet in 1917. J.V., fourth from the left with his arm resting on a truck, borrowed $100 to start this company around 1900 and pioneered Youngstown's carrying trade. He transported freight and baggage from railroad stations, branched into delivering newspapers, department store appliances, steel, and household moving. His father Johnny was born in County Mayo and came to Youngstown around 1860. In addition to J.V., Johnny's six children included James (a Youngstown police chief), a son Martin, and daughters Mrs. Thomas Fleming, Mrs. John Vahey, and Mrs. Lowry. (Courtesy of Mary Rita Carney.)

Many Irish businesses persist in the Mahoning Valley. Greg Carney, left, and his father, Thomas J. Carney, are shown here at the Carney-McNicholas office on Victoria Road in Youngstown. Greg and his brother T.J. are great grandsons of J.V. McNicholas, and their company is the modern offspring of the original J.V. McNicholas Transfer Company. Two other Youngstown transportation companies are operated by descendants of J.V. McNicholas: Aim Leasing under grandson Tom Fleming and Falcon Transportation under grandson Joe Fleming. (Courtesy of Thomas J. Carney Jr.)

The carrying trade provided business opportunities for other Irish families in Youngstown. Richard Gilmartin and his wife Maria Durkin were both born in Ireland and settled in Youngstown's "Smokey Hollow" neighborhood in 1905. For years, they operated a saloon on Valley Street. In 1915 following Maria's death, Richard started Gilmartin Transfer, hauling furniture and other goods by horse-drawn cart. He later purchased this motorized truck and became a familiar sight making deliveries with his dog Rover. The picture was taken around 1920. (Courtesy of Sara Gilmartin and MVHS.)

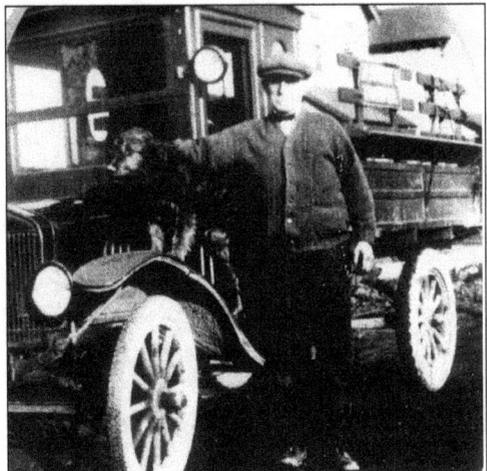

31

This photograph, taken in 1914, shows the William F. and Bridget (Burke) Lyden family, left to right, as follows: (back row) Michael, William G., Joseph, Paul, and Patrick; (front row) Edward, Bridget, Raymond Burke, May, William F., and John. William F. Lyden served two terms on Youngstown City Council (1900, 1913). Four of his children, William G., Patrick, Michael, and Mae, founded the Lyden Oil Company in 1919. In 1999, the company entered a partnership with Shell/Equilon to form the new company True North Energy LLC, which produces 320 million gallons of gasoline per year. (Courtesy of Paul Lyden.)

The Small family, successful in business and community affairs, were known for assisting recent Irish immigrants in their transition to life in the Valley. Mamie and Patrick Small lived on Youngstown's north side and were active in Irish affairs for many years. As early as 1907, Patrick served as secretary/treasurer of the AOH. In 1920, Florence Small became an early Valley female entrepreneur when she established the Small Insurance Agency on Federal Street. Not to be outdone, her sister Catherine opened an employment agency. Both businesses were highly successful and continued operation until the 1960s. (Courtesy of Father Richard Murphy.)

In 1867, brothers Thomas J. and William J. Vahey married twin sisters Katherine and Bridget Noonan in Ballinrobe, County Mayo. The couples, along with sister Mary Vahey Jennings, immigrated to the United States and eventually settled in Youngstown. This 1898 photograph depicts the four sons of Thomas J. and Katherine Noonan Vahey, from left to right, as follows: (standing) Patrick F. and Thomas J. Jr.; (seated) William H. and Jack. Brothers William H. and Thomas J. partnered in the Vahey Oil Company, established in 1893. The company sold kerosene for lamps and heating, progressed into oil and gasoline with the coming of the automobile, and by 1920 was grossing more than $1 million per year. It was dissolved in 1962 after 66 years in business. (Courtesy of Thomas J. Vahey IV.)

The Bresnahan family owns and operates Hynes Industries in Youngstown. Founded in 1925 by John F. Hynes and John D. Finnegan, the company was bought in 1966 by senior executives William W. Bresnahan and James P. Hyland. In this 2004 photograph are Board Chairman William W. Bresnahan in the center; (back row, left to right) David L., Timothy T., and Patrick C. Bresnahan; and (front row, left to right) Michael J and President William J. Bresnahan. The company supplies flat rolled steel products and custom engineered metal shapes to end-product manufacturers of major appliances, furniture, and hardware items throughout the United States.(Courtesy of William W. Bresnahan.)

33

A.P. O'Horo, a bricklayer and stone mason, immigrated to Ohio from County Mayo, Ireland, in 1855. He founded what is today one of the most well-respected general contracting companies in the tri-state area. In this 1913 photograph, the A.P. O'Horo Company's horse-drawn scraper is grading Steel Street on Youngstown's west side. The man in the derby is company founder Anthony O'Horo. Fourth from the right is his son, Anthony P. O'Horo, who became the company's second president. (Courtesy of Daniel J. O'Horo.)

The A.P. O'Horo Company has operated under four generations of the O'Horo family. Irish immigrant Anthony was the founding president, successors have been his son Anthony P., grandson Richard E., grandson Daniel J., and great grandson Daniel P. Daniel J. serves as board chairman in 2004 and is shown above doing foundation work on the Republic Steel (W.C.I. Steel) expansion in Warren. He is at the far right of this photograph, which was taken in the 1980s. The photograph below shows the YSU football stadium complex, which A.P. O'Horo also constructed. These are only two of the major projects completed by the O'Horo Company in recent decades. (Courtesy of Daniel J. O'Horo.)

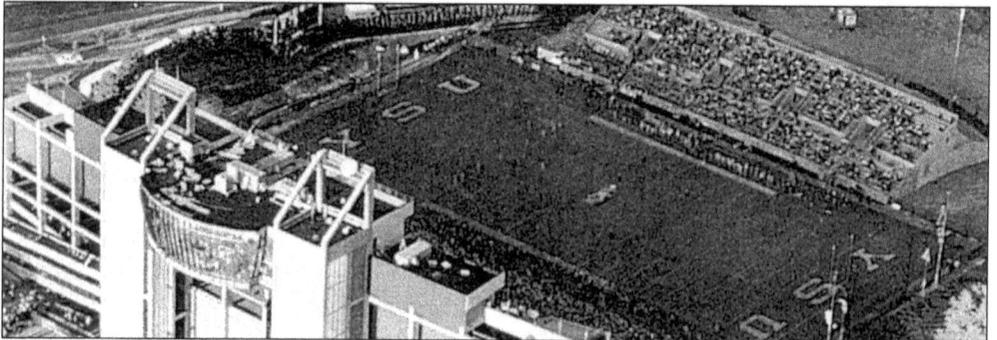

G.M. McKelvey and Company established a store in Hubbard in 1877. Then in 1891, the business incorporated and opened the department store that was a major presence in downtown Youngstown for decades. McKelvey's offered one-stop shopping for Valley residents seeking anything from the smallest implements to clothing, and they even carried full lines of appliances and home furnishings. This photograph shows the store as it appeared at the West Federal Street entrance in 1925. (Courtesy of MVHS.)

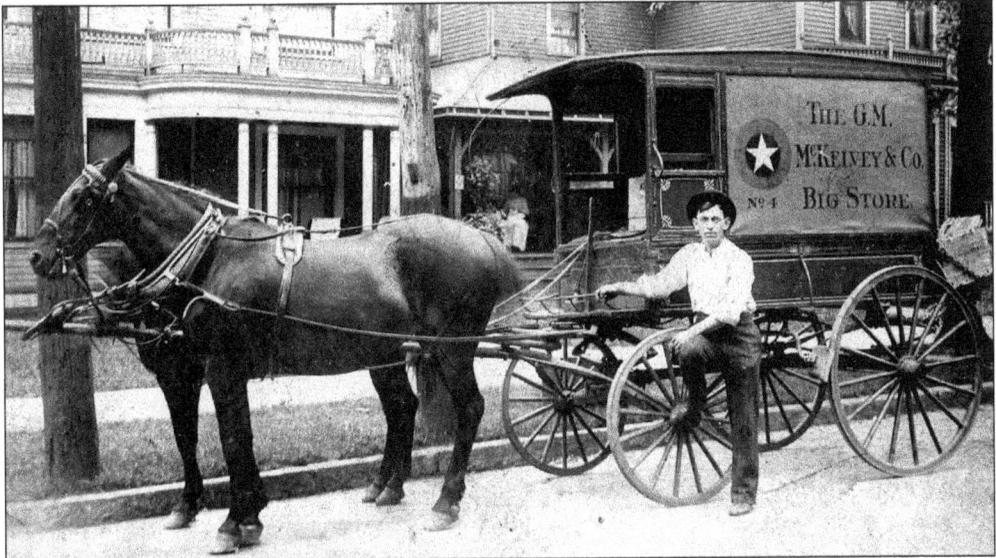

Home delivery was a featured service of the G.M. McKelvey department store from the time of its inception. This horse-drawn wagon was used to deliver furniture and appliances to homes throughout the Valley. This photograph was taken *c.* 1915. (Courtesy of MVHS.)

John O'Neill came from County Derry to Youngstown. This 1892 photograph shows John standing in the doorway of his West Federal Street grocery store. A typical "mom-and-pop" store, it was quite popular within the Irish community. John and his wife had six children; son John J. was among the first from Youngstown to enlist during World War I. (Courtesy of Bill Hucke.)

Some Irish families branched out to operate a variety of businesses. Mary Angela Gallagher Walsh stands in front of the T.C. Walsh Grocery and Provision Store on State Street, Youngstown. The boy is T. Carl Walsh with his dog Major. Mary Angela operated the store while her husband Thomas C. supervised operations at the Walsh slant coal mine. Both T.C. and Mary Angela were born in Derry, Ireland. T.C. also supervised the placement of roads into Mill Creek Park, for which he was commended by the park's founder, Volney Rogers. (Courtesy of Eileen Walsh Novotny.)

This 1911 photograph shows the M.J. Murphy Café on Poland Avenue in the "Old Kilkenny" neighborhood. The café occupied one side of a duplex while the other half was home to the Murphy family of ten children. During prohibition, the café was converted into a grocery store that remained in business until the depression year of 1932. Michael J. Murphy is shown holding his infant son Regis. (Courtesy of Patricia Murphy Hendrix.)

The House of Erin on Southern Boulevard has grown from its inception in 1992 to one of the Valley's major sources of Irish merchandise. Dick and Cathy Coughlin first began selling Irish wares out of their basement. They soon set up a stand at the Southern Park Mall where they worked part-time. In 1995, they opened a store on Southern Boulevard, handling a full line of Irish products. Wherever there is a major Irish function, such as the Gathering of the Irish Clans, the House of Erin can usually be found with a vendor's stand. (Courtesy of Dick Coughlin.)

Thomas W. Crogan Sr., founder of Crogan Plumbing and Supply, is pictured here with his wife of more than 70 years, Mary (Roche) Crogan. Both were children of Irish immigrants. The Crogans moved to Youngstown shortly after their marriage, where Thomas founded a plumbing company on Oak Hill. Today, the company is known as Crogan Plumbing and Supply and is operated by his grandson, Joe Crogan Jr. In addition to his business, Crogan served as president of the Particular Council of the St. Vincent DePaul Society for 32 years and as Youngstown's USO chairman during World War II, and he was one of the founders of the Assumption Nursing Home. (Courtesy of Anne Crogan, photograph by Joe Crogan.)

Thornton and Sons Heating, Cooling, and Plumbing began as a family business in 1965. The family patriarch, Thomas J., was born in Cornamora, County Galway, in 1929 and came to Youngstown at age 17. He is shown here in 1998 at left with his sons: (left to right) James (now managing the business), Michael (deceased), and Bryan (deceased). Over the years, the business was contracted for many notable projects including the Mahoning County Experimental Farm, and Kent State University's East Liverpool Campus. (Courtesy of Mary Thornton.)

Founded in 1964 by John Joseph "Joe" Flynn Jr., Flynn's Tires expanded to 23 retail stores with commercial and wholesale distribution in several states. The company operates out of its Mercer, Pennsylvania, headquarters under the management of the Flynn family. Outlets can be found throughout the Mahoning Valley, including a regional headquarters in Austintown. Shown here is "Flynnie," the company's leprechaun mascot with his 1927 Ford pickup. The picture was taken at "Flynn's Day," which was held by the Goodyear Rubber Company in Akron. Flynnie still frequently appears in many Mahoning Valley parades. (Courtesy of Tania Warminski.)

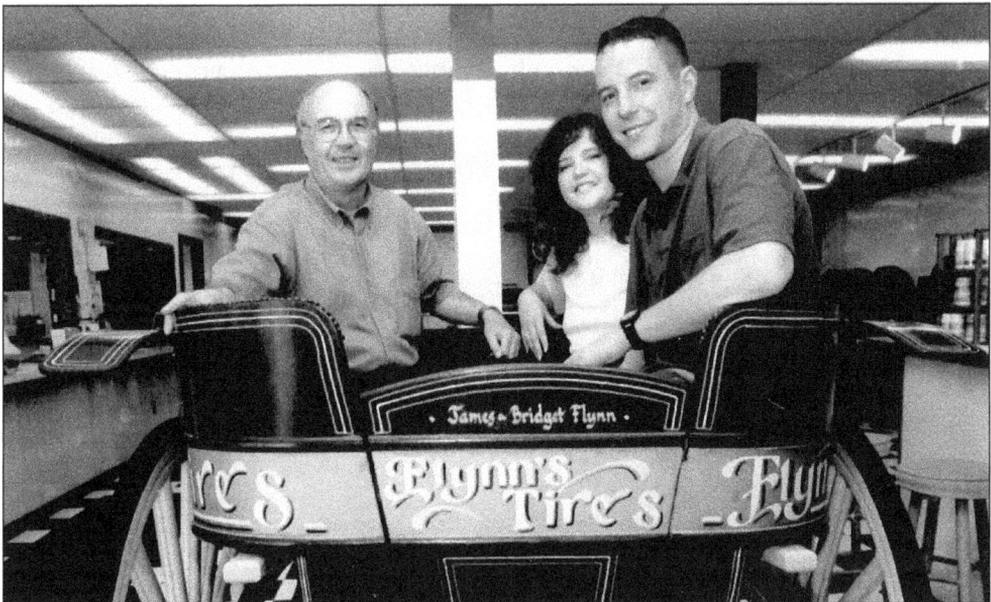

John J. "Joe" Flynn Jr. is seen here in Flynn's Tire Buggy. His daughter Tania and son John J. Flynn III are with him. Flynn retrieved the buggy from the family's ancestral home in Clydagus, County Roscomman, Ireland, and brought it to the Mahoning Valley, where he restored it and uses it for special events. The name on the back is in honor of Joe's grandparents, James and Bridget Flynn, original owners of the tire buggy. (Courtesy of Tania Warminski.)

John J. Buckley, an Irish immigrant and union activist, worked at Carnegie Steel in Sharon from 1871 until 1900 when he came to Youngstown where his sister owned a bar on East Federal Street. Buckley, who had been a delegate to union conventions and had once been offered the presidency of the Amalgamated Iron, Steel, and Tin Workers, bought the bar and quickly made it a successful gathering place for the Sons of Labor. Buckley and partner Patrick Hogan operated the bar as a gathering place for both management and labor groups until 1920, when prohibition forced it to close. (Courtesy of Paula J. McKinney.)

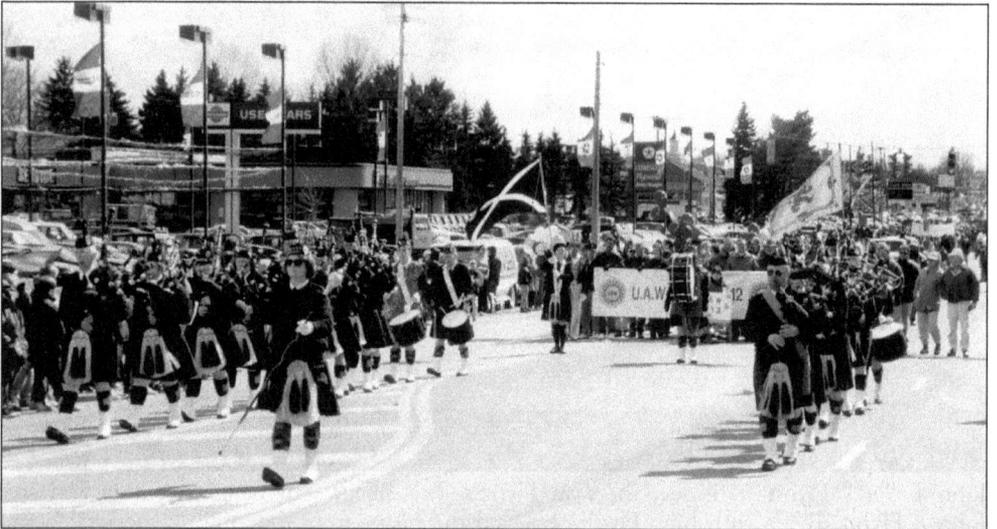

The United Auto Workers demonstrated Irish pride in the 1988 St. Patrick's Day parade. A large percentage of UAW membership is of Irish origin, and the local showed their appreciation and Irish pride at this event. (Courtesy of Sally Murphy Pallante.)

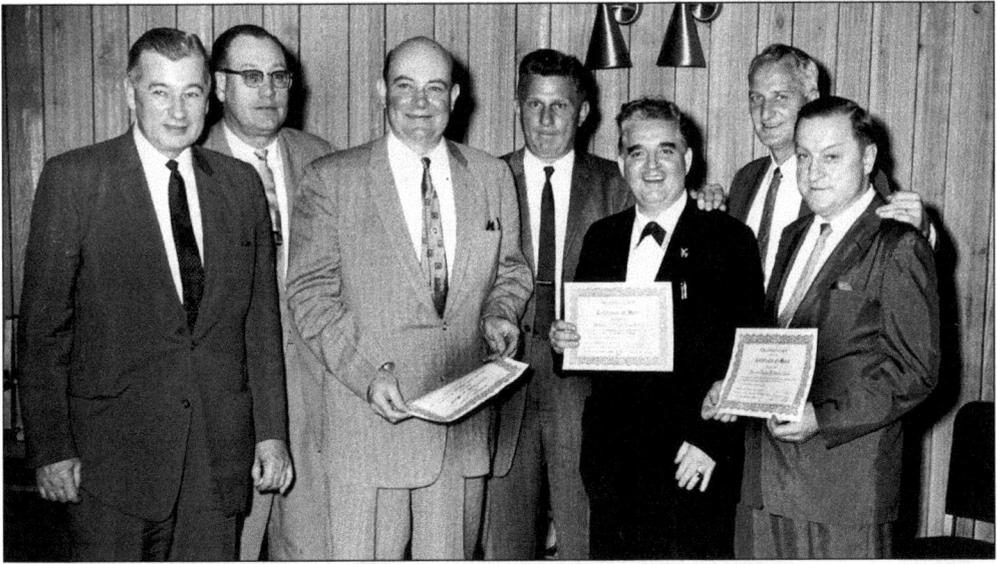

James P. Griffin (at left) was a leader of the labor movement in the Mahoning Valley for decades. Shortly after World War II, he was elected director of Youngstown's District 26 of the United Steel Workers of America and by the 1960s was negotiating national USWA contracts in Washington. He is shown here at the 1960 AFL-CIO awards banquet in Trumbull County with: (left to right) Russell Thomas, Mr. Kilpatrick, William Carney, Charles Carney, "Hank" Dineley, and "Bushel" Olenick. (Courtesy of MVHS.)

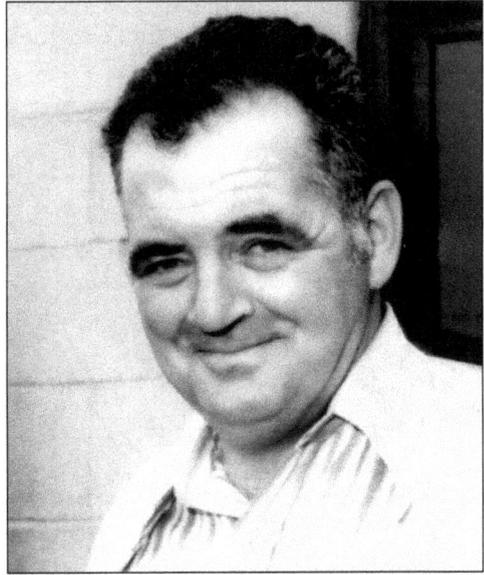

This father and son were leaders in both Mahoning Valley's labor movement and corporate management. Edgar H. McNulty (left) was the eighth of 13 children born to Irish immigrants John D. and Mary Coyne McNulty. He worked for 45 years at the Ohio Works of U.S. Steel where he became active in Local 1330 of the USWA, eventually serving as president. Edgar J. McNulty (right), the seventh of ten children born to Edgar H. and Marie O'Brien McNulty, rose from a position of brakeman with the Erie-Lackawana Railroad to the position of General Yardmaster of the entire Mahoning Valley District with Conrail. (Courtesy of Marie L. McNulty.)

When Senator John Glenn visited the Mahoning Valley in the 1970s, Bob and Scottie Hanahan were invited to a special reception. In 1956, Bob co-founded the architectural firm of Hanahan, Strollo, and Associates. Over the years, this firm has completed a long list of major design and engineering projects and has received numerous awards of merit from the American Institute of Architecture. In 2003, the firm won the AIA's most prestigious merit award. (Courtesy of Scottie Hanahan.)

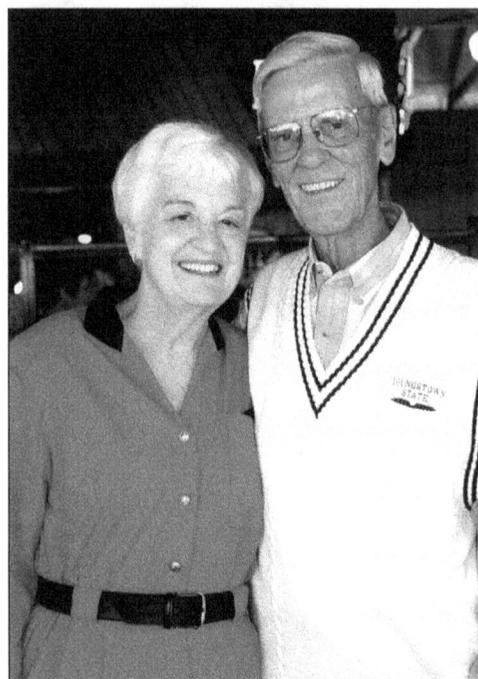

Donald E. Foley Sr. served the Mahoning Valley's home medical equipment needs for 33 years before retiring in 2000. In 1975, he founded the Patient Care Center and in 1982 Foley Home Medical, Inc. In 1990, he was named small business person of the year by the Youngstown Area Chamber of Commerce. A 1947 graduate of Ursuline High School, he was named a Distinguished Ursuline Alumnus in 1994. Don was a founder and first president of the Mahoning Valley Gaelic Society. He is shown here with his wife, Jeanne McLaughlin Foley. (Courtesy of Katie Foley Revak and MVHS.)

Sandy and "Irish Bob" Johnston prepare to participate in a St. Patrick's Day parade. In 1978, the couple bought a one-room neighborhood bar on South Avenue and converted it into Irish Bob's Pub. Over the years, they built up the customer base and expanded the pub into a full entertainment complex. Irish Bob's introduced many of the finest Irish musicians to the Youngstown area. In 1989, Bob was named Irish Man of the Year by AOH Division 6. (Courtesy of Sandy and Bob Johnston.)

The founders of McMenamy's in Niles are among these Leonard family members who gathered for a reunion in 2002. Several of the family joined to found McMenamy's, which is named for their mother. The business has rapidly grown into one of the Valley's premier entertainment complexes, encompassing a restaurant and numerous rooms for private and public gatherings. Each year, the Leonards organize what some believe to be the largest St. Patrick's Day party between Pittsburgh and Cleveland. (Courtesy of Dick Leonard.)

43

Fox Funeral Home, Inc. has been family operated for three generations. At its establishment in 1919, it was known as Edward J. Fox and Sons and was located on Chapel Place. An interim move placed the business on Oak Hill Avenue (pictured), and in 1963, it was moved to its present location on Market Street. Founder Edward J. Fox passed management duties to his sons James and John, and in 2004, the business is still operated by James E. Fox. John's son Edward J. Fox, representing the third generation, is now licensed and works for the firm. (Courtesy of Edward and Nancy Fox.)

Thomas J. McClurkin founded the McClurkin Funeral Home in Girard in 1958. He directed the firm until his retirement in 1987. His son Robert is now director, and another son, Patrick, is licensed and with the firm. In addition to Girard, McClurkin Funeral Home services both Liberty Township and McDonald. In 2003, the company expanded operations by purchasing the McVean-Hughes Funeral Home in Youngstown. (Courtesy of Robert McClurkin.)

The McVean and Hughes Funeral Service dates back to the 1860s when it was owned by Hugh McCrea. In 1886, Peter Gillen, who was born in County Sligo, bought the business and operated under the name Peter Gillen and Sons. After his retirement, Donald McVean joined the firm, which became known as Gillen-McVean and eventually as the McVean Company. John Hughes joined the firm and in 1967 became director under the name McVean-Hughes. In 2003, the firm was purchased by the McClurkin Funeral Home of Girard. The McVean family is shown here in 1920: (font row, left to right) John A McVean Sr., Atty Raymond J., and Joseph F; (back row, left to right) Dr. John A., Donald A., and Edward A. (Courtesy of Mary Lou Hughes.)

John Hughes served as director of McVean-Hughes Funeral Service for 30 years. He began his career at McVean while a student at Ursuline High School. After serving in the U.S. Air Force during World War II, Hughes married Mary Louise McVean and rejoined the firm. In 1967, he became director under the name McVean-Hughes. (Courtesy of *The Catholic Exponent.*)

Robert McCurdy served as president of the First National Bank for 27 years and is considered one of the "Builders of Youngstown." Born in Castle Finn, County Donegal, in 1842, he immigrated to the Mahoning Valley as an infant. A community activist as well as a banker, McCurdy was a chief sponsor of the YMCA, an elder of the First Presbyterian Church, a founding trustee of the Reuben McMillan Free Library, a trustee of the Rayen School, and a passionate supporter of Volney Rogers and his plans for Mill Creek Park. In 1868, McCurdy was elected the first treasurer of the City of Youngstown. (Courtesy of MVHS.)

Patrick M. "P.M." Kennedy was born in County Tipperary in 1853 and came to Youngstown as a youth. Educated in Youngstown schools, he became keenly interested in finance and eventually served as secretary/treasurer of the Excelsior Building Association. In 1889, he associated with the Home Building and Loan Company, which later became the Home Savings and Loan Company. He was elected vice president and eventually president of that company. In addition, he was a charter member of the Dollar Savings and Trust Company and was an organizer of the Central Bank and Trust Company. (Courtesy of Peggy Kennedy Yanek.)

\mathbb{T}hree

SPIRITUAL LIFE AND EDUCATION

Irish-American spiritual life accompanied the early Ulster Irish settlers in the Mahoning Valley where Presbyterian Churches were established to serve frontier congregations. It is believed that the first permanent church in the Mahoning Valley was Youngstown's First Presbyterian, which formed in 1799 under the pastorate of Reverend William Wick. The Presbyterian Society built a log structure at the corner of Wick Avenue and Wood Street in Youngstown, which served the congregation until a more formal building could be constructed. Early Roman Catholic immigrants could travel to Dungannon in Columbiana County where the first mass in the region was said in the frontier home of Daniel McCallister in 1812. By 1818, the Dungannon Church formed the congregation of St. Paul's, which worshiped in an attractive brick structure. In Youngstown, Reverend Thomas Martin celebrated the first Catholic services in the home of Daniel and Jane Shehy in 1826.

As the Irish population of the region grew, more formally organized churches were fashioned to serve the Roman Catholic community. St. Columba, which now forms the seat of the Roman Catholic Diocese of Youngstown, was the first permanent Catholic church in Youngstown. The congregation formed in 1847, and the first St. Columba Church was completed in 1853. Parochial education, always an important part of the Irish-American community, soon followed. St. Columba elementary school was educating Valley youth as early as 1861. By 1874, the Ursuline Sisters directed parochial education in Mahoning County. In the early twentieth century, the Sisters opened an annex to the St. Columba School in the Youngstown Irish neighborhood dubbed "Kilkenny," which was located in the area around Poland Avenue, Gibson Street, and Franklin Avenue. Today the parochial schools of the Mahoning Valley serve a wide range of students of all faiths offering quality education and promoting self-discipline.

As the largest and earliest group of Catholic immigrants, Irish Americans were among the first to assume leadership roles in the Roman Catholic Church in the United States. In the Mahoning Valley, the center of Roman Catholicism is the Diocese of Youngstown, established on May 15, 1943. In the ensuing years, many Irish Americans have served as bishop. In 1943, James Augustine "Jamie" McFadden of Cleveland became the first bishop of Youngstown, presiding over Ashtabula, Columbiana, Mahoning, Portage, Stark, and Trumbull Counties from St. Columba's. Bishop McFadden directed diocesan affairs for nine years, during which time he established the *Catholic Exponent* newspaper and helped boost registered membership in the churches of the diocese from 150,000 to over 200,000. James W. Malone, the third bishop to serve the Diocese of Youngstown, was a native son. His was among the founding families of the St. Dominic Parish where Malone attended grade school before graduating from Ursuline High School in 1937. Ordained in 1945, Malone rose quickly through the ranks and in June 1968 was installed as bishop, a rank he held until his retirement in 1995. During his long tenure as bishop, Malone was visible on the national level, acting as president of the National Conference of Catholic Bishops. He was also a driving force behind the Ecumenical Coalition,

founded in 1977 as an interdenominational organization established to pursue a worker buyout of a steel mill to preserve jobs. Although the "Save our Valley" campaign failed, the Ecumenical Coalition provided a model for community organizations that still exist in the Valley. In 2004, yet another Irish American leads the Diocese. Thomas J. Tobin, a native of nearby Pittsburgh, Pennsylvania, became the fourth bishop of the Diocese of Youngstown during a ceremony held at St. Columba's on February 2, 1996.

The beautiful windows above the entrance in this *circa* 1959 aerial photograph of the Fourth St. Columba Cathedral represent the life of Irish Saint Columba and portray the 23 symbols he used to teach the faith. (Reprinted from the Vindicator Printing Company, copyright 2003, used with permission.)

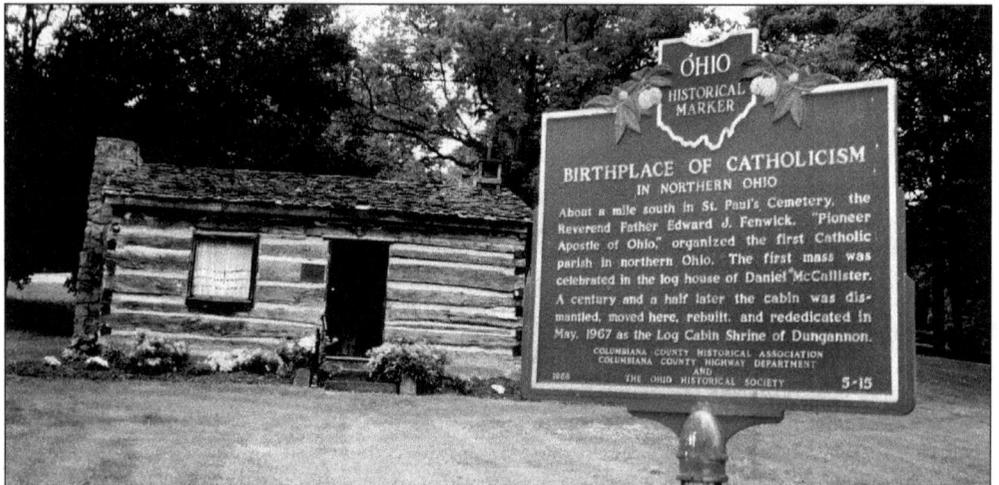

Construction of such projects as the Sandy and Beaver Canal attracted large numbers of Irish immigrant workers to Northeast Ohio. Father Edward Fenwick, the "Pioneer Apostle of Ohio," organized the first Catholic parish just east of Dungannon, Ohio, where in 1812, he said the region's first Catholic mass. Five years later, the brick church of St. Paul's was built to serve the growing parish's 15 Irish families. (Courtesy of Martin D. Pallante.)

48

The village of Dungannon, Ohio, was laid out by Irish immigrants Philip Erhardt and George Sloan and named for their native town. The village held strong appeal for the Irish from the nearby settlement of St. Paul. To accommodate the growing congregation, the original church cornerstone was incorporated into a new a new structure in 1846. Built on land donated by Mr. Philip Erhardt, St. Phillip Neri Church was dedicated in 1849. Several years later, the brick church of St. Paul was destroyed by fire, and in a symbolic gesture, the parishioners carried the salvageable bricks back to Dungannon. (Courtesy of Martin D. Pallante.)

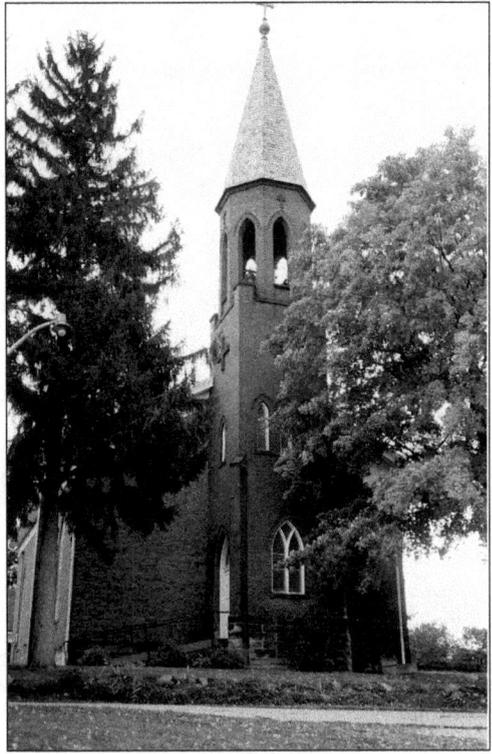

Father Eugene O'Callaghan, a native of County Roscommon, arrived in 1861 to lead the Roman Catholic community in Youngstown as the second resident pastor of Saint Columba Church. Father O'Callaghan addressed the needs of a growing Catholic population by opening St. Columba parish's second and larger church building on the south side of Wood Street in the mid 1860s. In 1871, he also brought the first Catholic school to the city of Youngstown at the southwest corner of Elm and Rayen. He administered sacraments over a large area of the Western Reserve, presiding at mass on Sundays in Warren, Niles, and Hubbard, as well as Youngstown. (Courtesy of the Diocese of Youngstown and Joan Reedy Lawson.)

Catholic School Education was highly valued by Irish immigrants in the Valley. Postmarked "Youngstown, Ohio, June 12, 1908," this image portrays the second St. Columba Church, built by parishioners under the guidance of Father Eugene O'Callaghan. Seen in the upper right, the church sits atop a bluff above the Erie tracks while the steel mills thrive in the distance. Also visible just across Wood Street is the new St. Columba Church, constructed in 1903. (Courtesy of Sally Murphy Pallante.)

The St. Columba School third-grade class poses in front of the parish's red brick school at the corner of Elm Street and Rayen Avenue, c. 1910. Ursuline Sister Francis DeSales stands on the left and rector Father Edward Mears, at their right. (Courtesy of Sister Bridget Nolan.)

The St. Ann Church, school, and rectory proudly served Brier Hill for 91 years. Pictured here in their best Sunday clothes are the 1917 graduates of St. Ann: (front row, left to right) Tom McNicholas, Mary Harrison, Bob Fleming, Father John P. Barry, Mary McMahon, George Assion, and Annabel McFarland; (second row, left to right) Ed O'Connor, Isabel Noble, Edgar Fair, Margaret Dean, ? Carroll, and unidentified; (third row, left to right) ? Fisher, Joe Holmes, Pearl Laffey, J. Collins, Agnes Connelly, and ? Collins; and (fourth row, left to right) Joe Saunders, Dave Welsch, Elinor McFarland, Fidel Reiger, and Florence Joyce. (Courtesy of Florence McNicholas.)

Father James "Jamie" McFadden was born on Christmas Eve 1880, the second of 12 children of Irish immigrants Edward and Mary Cavanaugh McFadden. Father McFadden was ordained in Cleveland in 1905 and was made Domestic Prelate, Monsignor, by Pius XI in 1927. In 1943, he became the Diocese of Youngstown's first bishop. (Courtesy of the *Catholic Exponent*.)

Archbishop John T. McNicholas OP of Cincinnati presides at the July 22, 1943, installation of Bishop James A. McFadden (seated wearing miter) at the Cathedral Church of St. Columba. The first bishop of Youngstown takes as his Episcopal motto, "With Charity Toward All." (Courtesy of the *Vindicator* Printing Company, copyright 2003.)

Emmet Michael Walsh was born in 1892 and ordained a priest in 1916. Consecrated bishop of Charleston, South Carolina, in 1927, he was appointed coadjutor bishop of Youngstown in 1949 and in 1952 was elevated to bishop of Youngstown. Walsh University is named in his honor. In 1954, lightning struck St. Columba Cathedral. Eleven fire companies, led by fire chief John R. Lynch and assistant Frank L.Quinn, answered three alarms and fought the blaze to no avail. A new cathedral, constructed under Walsh's guidance, was completed in 1958. (Courtesy of the *Catholic Exponent.*)

Father Charles Martin, St. Patrick pastor for 11 years, is seated in the center of this 1912 First Holy Communion class. Founded in May 1911 to serve Youngstown's south-side families, St. Patrick parish opened its school in 1914 under the direction of Father Martin, Sister Coletta, and Sister Theresa McMahon. (Courtesy of Sister Bridget Nolan.)

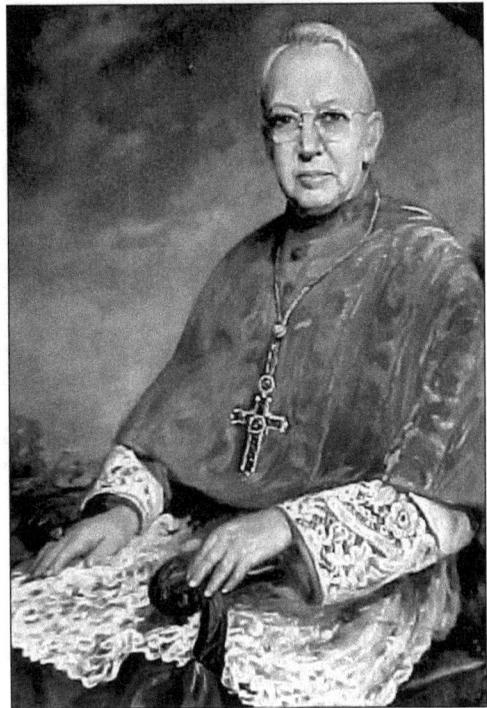

(*left*) Ordained May 26, 1945, Father James William Malone was assigned as an associate at St. Columba, became superintendent of diocesan schools in 1952, and was installed as the third bishop of Youngstown in June 1968. Before retiring in 1995, Malone held numerous prominent committee posts and was elected to head the United States Catholic Conference and the National Conference of Catholic Bishops in 1983. (Courtesy of the *Catholic Exponent*.)

(*right*) The December 24, 1945, Youngstown *Vindicator* headline read, "Pope Pius Names Mooney Cardinal." Consecrated archbishop in 1926, bishop of Rochester, New York, in 1933, and first archbishop of Detroit in 1937, Youngstown's Edward Aloysius Mooney formally received the Red Hat of Cardinal on February 18, 1946. Cardinal Mooney High School on Erie Street in Youngstown, Ohio, is named in his honor. (Courtesy of Cardinal Mooney High School Archives.)

Reverent concentration is visible on the face of Ursuline Sister Margaret Mary McCabe as she carefully counts and packages altar bread. In the 1950s, the Sisters at the Rayen Avenue Convent filled orders from each parish for the specially-made bread that would be consecrated during mass. (Courtesy of Sister Bridget Nolan.)

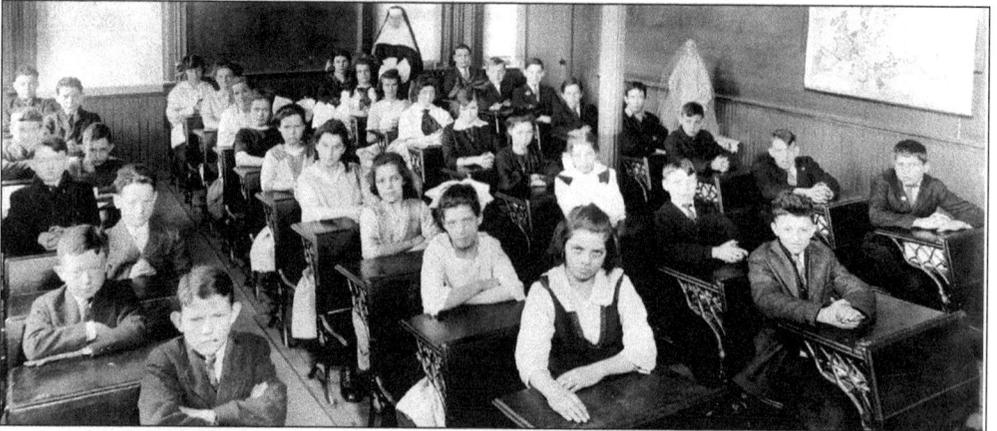

The story of the Ursulines and their impact on Catholic education in Youngstown began September 18, 1874, when Bishop Richard Gilmour of Cleveland sent six Ursuline Sisters to begin a new religious community in Youngstown at the request of St. Columba Pastor Reverend Patrick Brown. Within four days, the Sisters opened classes for 60 girls at St. Columba's three-year-old school. (Courtesy of Sister Bridget Nolan.)

The St. Angela Orchestra was made up entirely of nuns, who in addition to teaching, also performed concerts for the sisters of the community and on occasion for the parents of the orchestra members. (Courtesy of Sister Bridget Nolan.)

54

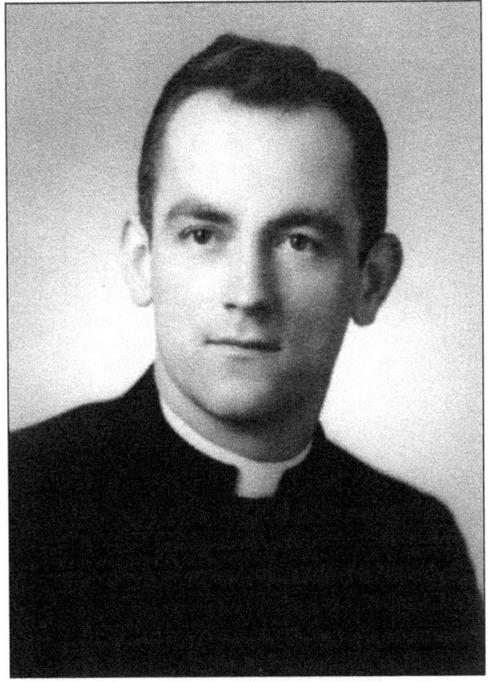

(*left*) Father John I. Moran was the state chaplain for the Ancient Order of Hibernian from 1907 to 1914. In 1906, he was appointed pastor at Sacred Heart Church. (Courtesy of Richard Quinn.)
(*right*)Reverend John P. Gallagher was installed as the Mahoning Valley Gaelic Society's first chaplain during the society's fourth annual Holy Family Church Communion Breakfast on Sunday, May 19, 1963. Father Gallagher was ordained in September 1944. (Courtesy of Roberta Robinson and Daniel Gallagher.)

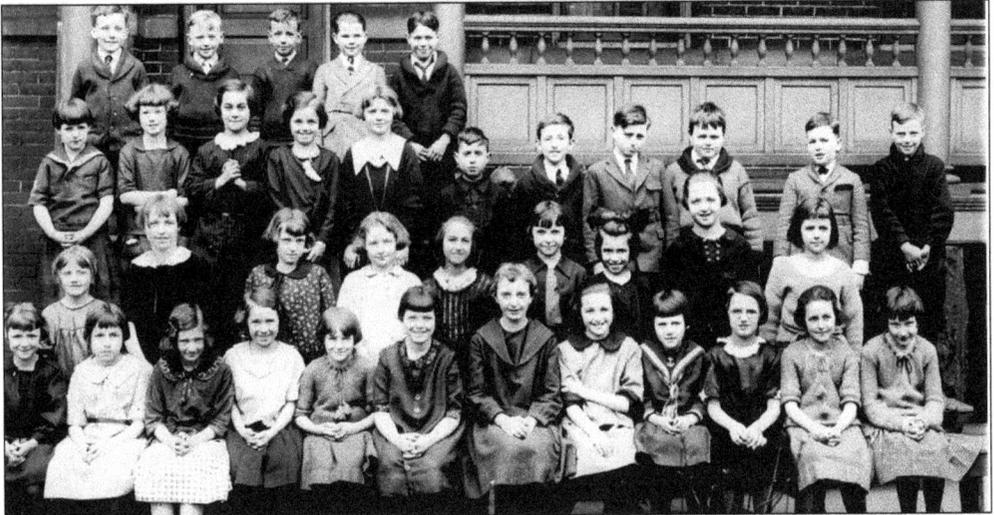

Sister Evangelista Mahoney's third- and fourth-grade class is pictured in front of the original Ursuline Academy, *c.* 1920. Ground was broken for the Sisters' original 115-foot by 48-foot four-story brick convent on May 18, 1896. In 1905, the Ursuline Sisters expanded and established the Ursuline Academy of the Holy Name of Jesus at the 217 West Rayen Avenue next to St. Columba School. (Courtesy of Sister Bridget Nolan.)

Under the guidance of Mother M. Joseph Hopkins, the girls' school expanded to the Chauncey Andrews Mansion on Wick Avenue to include grades nine through twelve. Seniors from Ursuline High School's first graduating class in 1920 are pictured with their teachers: Grace Tyrell and Margaret Heinrich (both seated); Ursula (O'Neill) Bainbridge (kneeling); and (standing, left to right) Mother Agnes Ryan, Zella Jennings, Mary Gengenbacher, Mildred Kofler, Alma Caposell, Rose Parilla, and Sister Irene Breen. (Courtesy of Sister Bridget Nolan.)

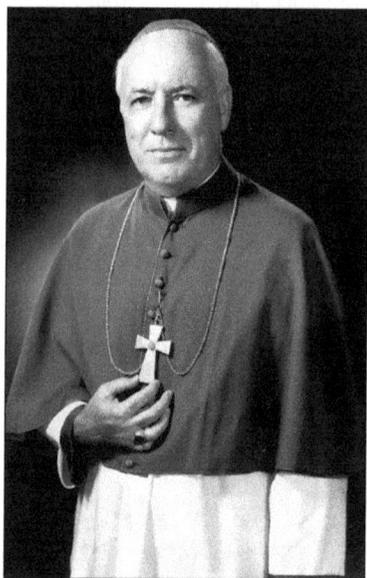

(*left*) William Anthony Hughes, ordained a priest of Youngstown in 1946, was first assigned to St. Charles Church in Boardman and became founding principal at Cardinal Mooney High School in 1956 and then diocesan superintendent of schools in 1965. He was designated a monsignor and diocesan vicar of education in 1961 and then vicar general in 1972. On September 12, 1974, he was elevated to auxiliary bishop of Youngstown. (Courtesy of the *Catholic Exponent.*)

(*right*) St. Patrick's and other diocesan school children found numerous ways to help the underprivileged and families suffering hardships in the era surrounding World War II. Daniel J. O'Horo is the boy on the far right. (Courtesy of St. Patrick's Church.)

Bishop Thomas J. Tobin was ordained in 1973 and served in several Pennsylvania parishes and as administrative secretary before being named associate general secretary of the Pittsburgh Diocese in 1987. In 1990, he became vicar general and general secretary. He was ordained to the Episcopacy in 1992, serving as auxiliary bishop of Pittsburgh until coming to Youngstown. During a ceremony at St. Columba Cathedral on February 2, 1996, he was installed as the fourth bishop of the Diocese of Youngstown. In leading the Jubilee 2000 celebrations and mindful of his role as "spiritual shepherd," Bishop Tobin invited Youngstown Catholics to partake in a deeper faith journey with him, sharing the ideals of his motto, "Strong, Loving, and Wise." (Courtesy of the *Catholic Exponent*.)

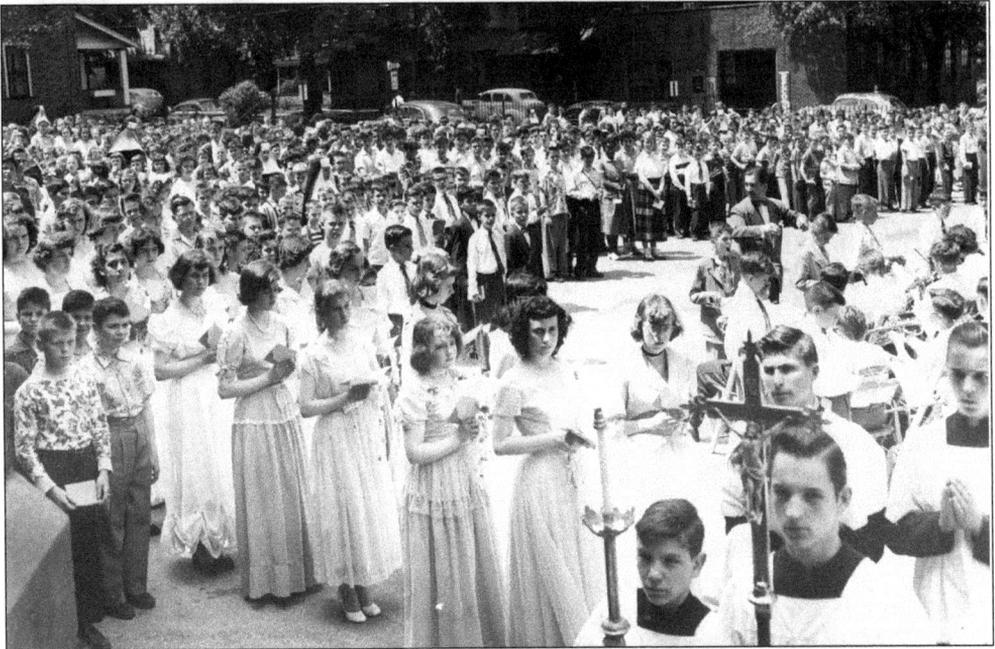

At the annual St. Patrick's May Crowning, students, their teachers, the school band, and interested parishioners processed into St. Patrick's Church in 1953 to pray the Rosary. In 2003, Bishop Tobin revitalized devotion to the Blessed Mother and encouraged Catholics to pray the Rosary and honor Mary. (Courtesy of St. Patrick's Church.)

Father William James Manning of Warren was appointed the first pastor of Immaculate Conception parish in July 1882. The parish territory had some 200 families, many of Irish descent and employed at the old Valley Mill or Himrod Furnace Company. Father Manning celebrated the first mass in the frame church in December 1882. The large crowd, pictured here

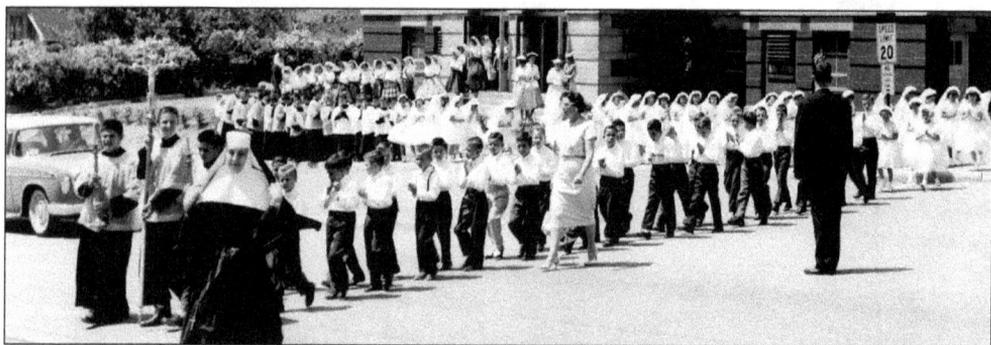

Utilizing four rooms on the first floor of the old frame church, Immaculate Conception School opened on February 12, 1883. In 1906, Father M.P. Kinkead, Immaculate Conception's second pastor (1899–1910), opened a new brick school on the same site as the original frame structure. By 1965, the parish included 1,500 families with 600 children in school. Pictured here is a first communion class procession being led across the street to Immaculate Conception Church by altar boys and an unidentified Ursuline Sister. (Courtesy of Sister Mary Lee Nalley and Peg Nalley McDonough.)

standing in front of Immaculate Conception School, gathered on June 23, 1918, to celebrate the 25th Anniversary of the Ordination of Father John Rourke Kenny, who served as pastor of Immaculate Conception from 1910 to 1925. (Courtesy of Sister Mary Lee Nalley and Peg Nalley McDonough.)

Sister Jerome Corcoran and Sister Mary Dunn have worked in many capacities in their vocation. In May 2002, the Youngstown Community School, a charter school on Youngstown's south side, welcomed its benefactors and the public to the dedication of its new building on Essex Street. Several school children are pictured with the principal of the school, Sister Mary Dunn, and with Sister Jerome Corcoran, the executive director of Developing Potential, Inc., which includes the Mill Creek Children's Center and the Youngstown Community School. (Courtesy of Sister Mary Dunn.)

Pictured here are members of the St. Brendan youth group. Members of St. Columba and St. Patrick Parishes residing on Youngstown's west side formed St. Brendan Parish upon the approval of Bishop Joseph Schrembs. Under the pastoral guidance of Father Crehan, the newly formed church celebrated its first mass May 6, 1923, in the old Perkins public school building located at the northwest corner of Schenley and Mahoning Avenues. Construction on a permanent church and school began 1924. (Courtesy of St. Brendan's Church.)

Sister Rosemary O'Brien of Humility of Mary Sister (HM) and St. Edward first-grade teacher from 1937–76 came to be loved by several generations of north-side families. The Sisters of the Humility of Mary of Villa Maria, Pennsylvania, served in Youngstown as teachers and administrators at nine local schools: St. Anne, St. Anthony, St. Brendan, St. Edward, St. Edward Jr. High, St. Joseph, Cardinal Mooney, Ursuline High Extension, and Ursuline High School. (Courtesy of Sister Joanne Gardner.)

When March 17th drew near, the music of "Old Ireland" filled the halls and auditoriums of area schools, and children of all nationalities joined in the merriment of Irish song and dance. The annual St. Patrick's show was an anticipated event at St. Patrick's parish in the late 1940s. Pictured here are Sheila Walsh (angel), James Patrick O'Neil (St. Patrick), Penelope Ann Marquette (angel), and a smiling cast dressed in green with shamrocks. (Courtesy of St. Patrick's Church.)

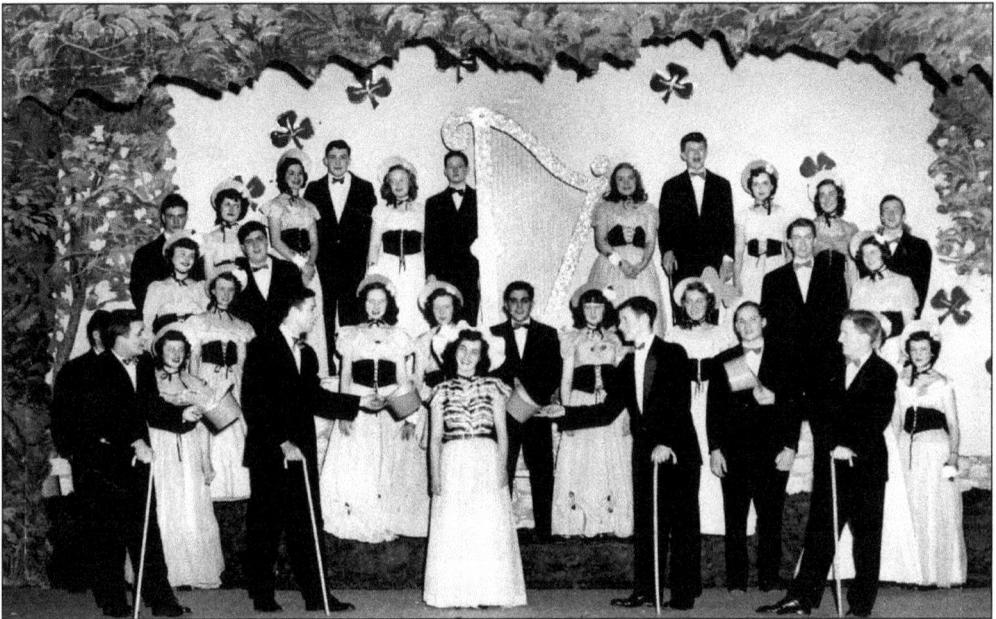

Through the years, the lilt of Irish songs has echoed across the stage at Ursuline High School in celebration of St. Patrick's Day. It was a grand day for the Irish in 1948 when this handsome and beautiful cast performed Irish favorites so typical of the shows of the era, none of which was complete until the singing of "Danny Boy." In this highly decorative setting, the ensemble gathered around the harp, the national symbol of Ireland, as four gentlemen tip their green top hats and serenade a lovely colleen (girl) in their best Irish tenor voices. Chuck Lehnerd (on the right of the colleen) saved this photograph. (Courtesy of Patricia Lehnerd.)

Young ladies dressed in their best frilly dresses and young gentlemen outfitted in knickers with knee socks pose for their 1930 eighth-grade graduating class picture with St. Columba parish priest and pastor, Monsignor Joseph Trainor. Over the years, many kept in touch and often their paths did cross; eventually in 1980, 23 classmates met for their 50th Reunion. The evening was occupied with conversation, reminiscing, and renewing old friendships. Fifty years later, they posed again for a class picture, the smiles tell the rest of the story. (Courtesy of Anthony J. Murphy.)

This is the 50-year reunion picture for the 1930 class of St. Columba. The classmates names are from the 1930 records (not in order): Eleanor Ramsey, Joseph Corcoran, Mary Theresa Gillespie, William Flynn, Irene Corcoran, Harry Ryan, Mary Rita Doyle, Laura Thrasher, Michael Thoumy, Paul Kane, Eugene Pautot, Joseph Collins, Rita Collins, Michael Carlini, Adel Carlini, Eileen Kaiser, Martha Reagan, Eleanor Manley, Thomas Morley, William Casey, Anthony Murphy, Harry Collins, Margaret Malloy, Margaret Barry, Mary Louise Doyle, Angelo DeMichael, Theresa Marinelli, Florence Adams, Frank Kalosky, Harrison Heydle, Henry Rupp, Samuel Sabine, ? Sullivan, Matilda Malloy, Rose Ponzi, and Andrew Owens. (Courtesy of Sister Jerome Corcoran.)

Four

POLITICS AND GOVERNMENT

In the late 1800s, the Mahoning Valley was a stronghold for the Republican Party. The dominance of the steel industry meant that issues such as a high protective tariff and a stable currency were key. Republicans came to dominate United States politics with the election of Irish-American William McKinley, a native of Niles, and (with the exception of Woodrow Wilson) would continue to dominate the White House until the Great Depression. McKinley was educated in Niles and Poland before settling in Canton, then served bravely during the Civil War, and finally pursued political office. But not all political trends benefited immigrant Americans. In the first decades of the twentieth century, some political activists sought to impose their own brand of morality on the immigrant community by outlawing gambling, forbidding work or recreation activities on Sunday, and eventually endorsing the prohibition of alcohol.

A divide among Valley residents emerged in the 1920s with the rise of Ku Klux Klan, which unlike the Klan of Reconstruction, took aim at immigrants and Roman Catholics as well as African Americans. Some Mahoning Valley communities, such as Niles, elected Klan mayors. A November 1924 Klan rally planned for Niles was met with resistance on the part of Irish and Italian residents, and a day-long riot ensued. The violence was so intense that the governor was forced to send out the National Guard. Scandal and misconduct led to a demise of the organization and split Valley Republicans into pro- and anti-Klan factions. In Youngstown, this division paved the way for the election of the Irish-American mayors, in 1927 and 1931, both Democrats. Joseph Heffernan, who was the first Irish American to break into the mayor's office since Mathew Logan in the late nineteenth century, was a strong anti-Klan activist and is credited with assisting in the theft and publication of a local Klan membership roster.

Once the Klan dispersed in the late 1920s, Irish Americans found their way into many prominent roles in Mahoning Valley and national politics. Several of the Valley Irish have served the region in Congress, including 16-term representative Michael J. Kirwan, who was well known for his willingness to fight for the rights of working men and women. Charles J. Carney, a life-long Valley resident, served in the Ohio State Senate, then succeeded Kirwan in the House of Representatives. In 2003, attorney Tim Ryan, a native of Niles, was elected to represent Ohio's 17th congressional district, continuing the presence of Irish Americans representing the interests of the Mahoning Valley in Washington.

Many more Valley Irish have served the community in local and state politics. Thomas J. Carney and his son and namesake can count several decades of service on the Mahoning County Commission. The judicial bench in the region has also been a hallmark of Irish achievement, including Probate Judge Leo P. Morley, Seventh District Court of Appeals member Joseph E. O'Neill, and Mahoning County Common Pleas Court Judges Martin P. Joyce and Maureen Cronin. In the late twentieth and early twenty-first century many Irish Americans have also

continued the tradition of mayoral service, most notably Francis "Spike" McLaughlin, who served as mayor of Canfield for 26 years. George M. McKelvey served eight years as Mahoning County treasurer and in 2004 is mayor of Youngstown.

This unique 1960s night photograph was taken in Canfield, Ohio, by Ridge Shannon as the popular presidential candidate John Fitzgerald Kennedy greeted area families lining the Canfield-Niles Road. (Courtesy of Ridge Shannon.)

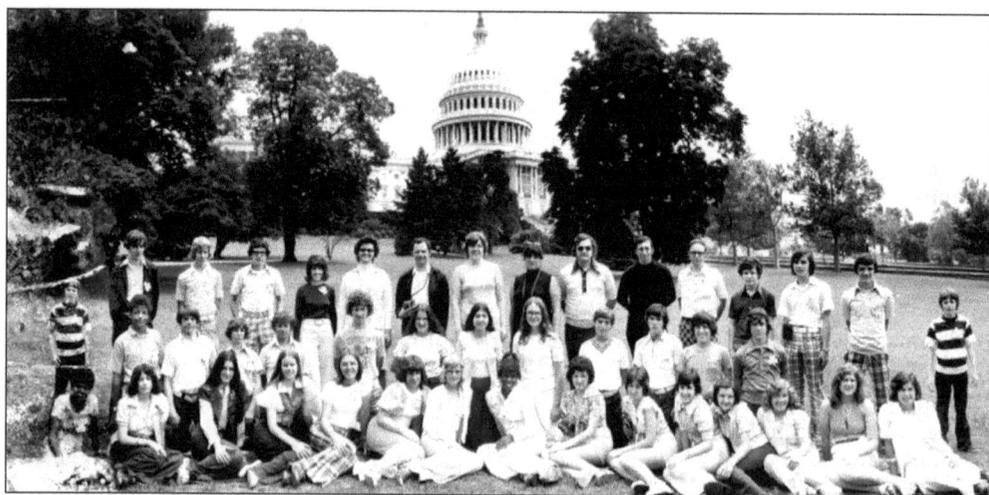

A group of students from the 1974 Ursuline High School class visit the nation's capital for a firsthand look at the workings of the federal government. (Courtesy of MVHS.)

64

William McKinley, 25th president of the United States, was born in Niles on January 29, 1843. His great grandfather immigrated to America from Ballymoney, County Antrim, in the early 1700s. The family moved to Poland in 1852 so that McKinley could attend the Poland Academy School. At the onset of the Civil War, McKinley joined the Union Army (above left) and served with valor, advancing to the rank of major. His political career included six terms in Congress, two terms as Ohio's governor, and two terms as president of the U.S. During his second term in office, McKinley was assassinated. The McKinley Birthplace Memorial is located in Niles. (Courtesy of Niles Historical Society.)

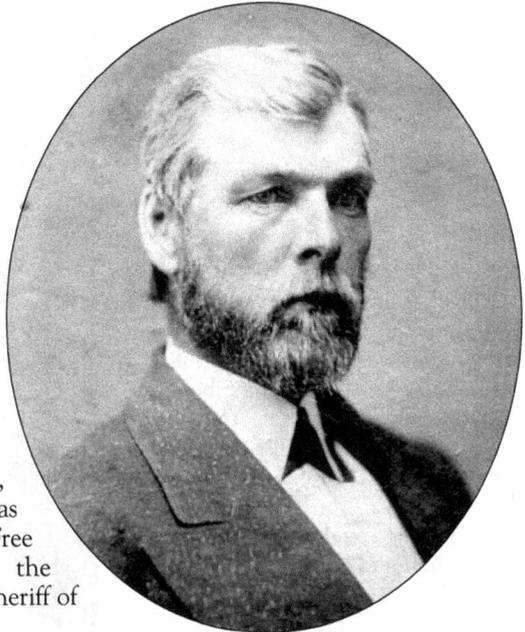

Beginning with the year 1876, Mathew Logan was elected to four terms as Youngstown's mayor. His parents, Hugh Logan and Rose McKenna, came to America in the early 1800s from County Londonderry and settled in New York City where Mathew was born in 1828. In 1862, Logan moved to Greenville, Pennsylvania, and then on to Youngstown where he was a railroad supervisor. A member of the Free and Accepted Masons, Logan attained the Knight Templars degree. He also served as sheriff of Mahoning County. (Courtesy of MVHS.)

Born Christmas Day 1883 in County Kerry, Stephen Sullivan immigrated as a teen to Youngstown. Following graduation from the Wood Street School and a serious accident at a local mill where he lost an arm, Sullivan attended Hall's Business College. Appointed and elected to a number of local government positions, Sullivan was subsequently elected as a Republican into the U.S. House of Representatives. He is best remembered as an outspoken supporter of city parks, playgrounds, and athletic fields and as "the father" of the local bus system. (Courtesy of Pat Sullivan.)

In 1927, Joseph Heffernan was elected the first Irish-American mayor of Youngstown of the twentieth century. Although he was known for devoted service to the community, he is best remembered as a crusader against the activities of the Ku Klux Klan, which threatened immigrants and African Americans during the 1920s. In this effort, Heffernan is credited with assisting in the theft and publication of a local Klan membership roster. (Courtesy of MVHS.)

John F. Kennedy visits with mill workers along West Federal Street, one of many stops made in the Mahoning Valley during his successful run for the U.S. presidency in 1960. (Photograph courtesy of Paul R. Schell; reprinted from the *Vindicator*©, Vindicator Printing Co., 2003.)

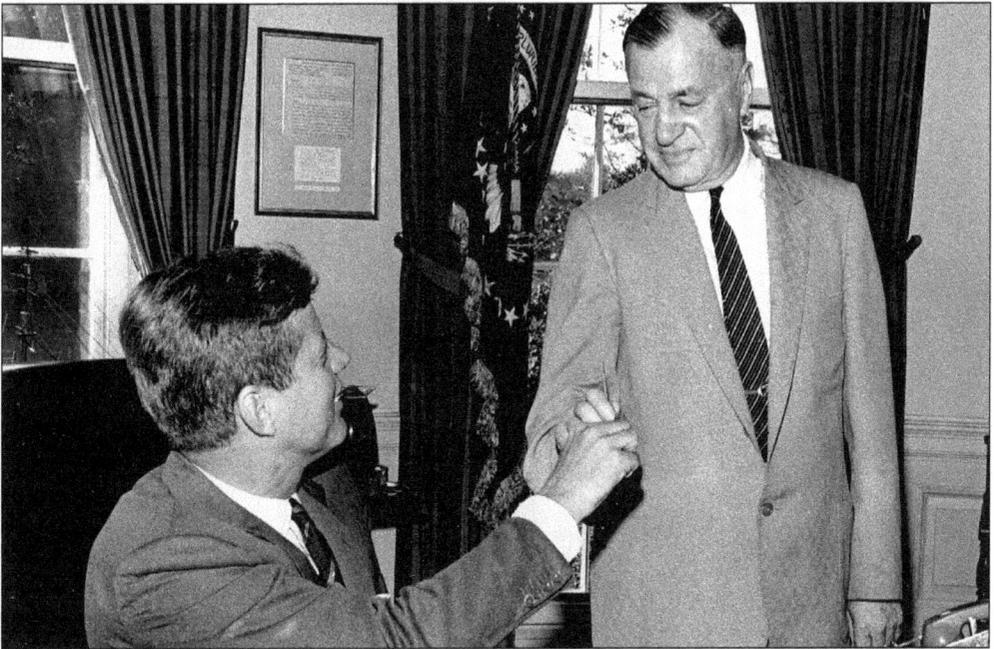

Michael J. Kirwan, who represented the Mahoning Valley in the U.S. House of Representatives for 16 terms, is seen here at the White House with John F. Kennedy. Kirwan was born in Wilkes-Barre, Pennsylvania, on December 2, 1886. He moved to Youngstown at the age of 20 and served one term on Youngstown's city council before seeking higher office. Kirwan's pride in his heritage was reflected in his elation upon receiving the "Mr. Democrat" statue, which depicts an Irish workman with his sleeves rolled up ready to fight. President Lyndon B. Johnson presented five such statues, but it was Mike Kirwan who made the symbol famous and forever associated with the Irish-American congressman from Youngstown. His constituents best remember him as a fighter for the needs of working men and women. (Courtesy of Joyce Kale-Pesta.)

Attorney Richard P. McLaughlin was born and raised in Youngstown. Most of his adult life has been devoted to serving the Democratic Party at the national, state, and local levels and to active participation and leadership in Irish organizations and functions. McLaughlin is a graduate of Ursuline High School, Youngstown State University, and Georgetown University where he received a law degree. He is pictured above with former Ohio Senator John Glenn, whose Trumbull County campaign McLaughlin managed. McLaughlin is a principal in the law firm of McLaughlin and McNally. (Courtesy of Richard McLaughlin.)

Congressman Charles J. Carney, a lifetime resident of the Mahoning Valley, is shown here (far left, above) with a group of labor leaders and former Ohio Governor John Gilligan. He was educated at local schools, including Youngstown State University. Carney was a member of the Ohio State Senate from 1950 to 1970, serving the last years of his term as minority leader. Elected to fill the vacancy caused by the death of Congressman Michael Kirwan, Carney served the Valley in the U.S. House of Representatives from 1970–79. He died in 1987. (Courtesy of MVHS.)

On January 7, 2003, Tim Ryan was sworn in as the youngest Democratic member of the 108th Congress to represent Ohio's 17th congressional district. Ryan is a life-long Niles resident. He graduated from John F. Kennedy High School in Warren and attended Youngstown State University. A bachelor's degree in political science from Bowling Green State University and a law degree from Franklin Pierce Law Center soon followed. Tim is co-chair of the House Manufacturing Caucus and serves on the Education and Workforce committee, the Armed Services committee, and the House committee on Veterans affairs. Ryan is involved in many community organizations and is an active member of the AOH. (Courtesy of Tim Ryan.)

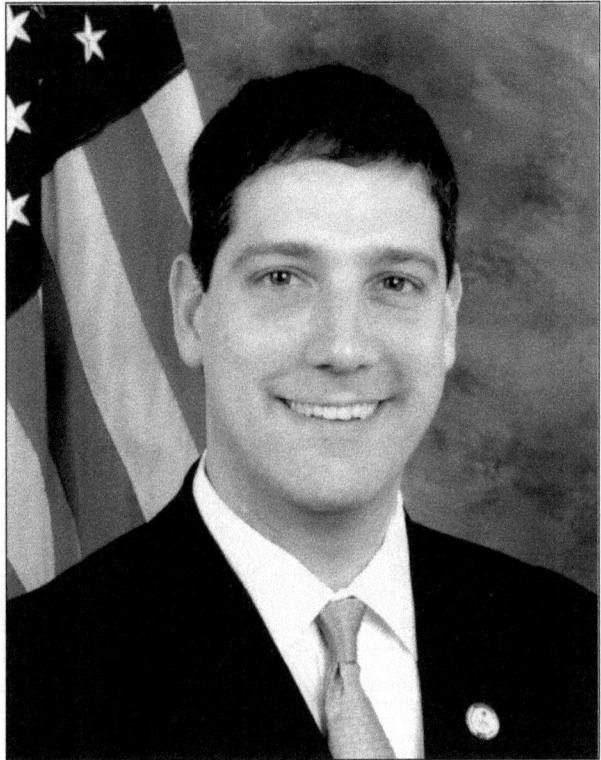

Ohio State Senator Robert F. Hagan is a life-long resident of the Mahoning Valley and graduate of Ursuline High School. A locomotive engineer by trade, Hagan has been honored for his legislative activities and is affiliated with the Youngstown State University Labor Advisory Committee. Hagen was instrumental in bringing an Ohio Bicentennial Bell casting event to the 2003 Canfield Fair. (Courtesy of IAAS.)

(*left*) In January 1955, James McNicholas was named Hibernian of the Century at a Sunday evening testimonial dinner given by the local AOH chapter in honor of his 75-year membership in the organization. McNicholas was the former Youngstown chief of police. (Courtesy of Mary Rita [McNicholas] Carney.)

(*right*) In 1942, Thomas J. Carney was elected Mahoning County Commissioner and was returned to that office in every election until his death on June 22, 1965. Carney was an active member and instructor at the Youngstown Patrician Club and was involved in all sports, serving as director of the local Golden Gloves Tournament for 36 years. (Courtesy of Thomas Carney Jr.)

Carney's son and namesake, Thomas J. Carney, was born February 17, 1934, in Youngstown, Ohio. Tom, an Ursuline alumnus, earned a degree in Business Administration from Youngstown State University. Tom's political career began in 1970 when he was elected Boardman Township Trustee. In 1973, he was elected to represent the 71st District in the Ohio House of Representatives. He was subsequently elected majority whip, and served on a number of key committees before returning home to fill several terms as Mahoning County commissioner. (Courtesy of Mary Rita Carney.)

Probate judge Leo P. Morley grew up on Youngstown's west side, attending St. Brendan's School and Ursuline High School, before enlisting in the U.S. Army in 1944. Morely served with valor in World War II and Korea, then earned a law degree from Western Reserve University. His tenure as probate judge began in 1985 and ended with retirement in 1997. Morley is a member of the Gaelic Society and was honored in 1972 as Irishman of the Year. (Courtesy of Leo P. Morley.)

Judge Joseph E. O'Neill (flanked by President John F. Kennedy and Congressman Michael Kirwan) graduated from the Rayen School, John Caroll University, and he earned a law degree at the Youngstown College of Law. In 1966, O'Neill was elected to the bench of the Seventh District Court of Appeals, an office he held for 30 years. A past president of the AOH, O'Neill was honored in 1973 as Irish Man of the Year. (Courtesy of the *Vindicator* Printing Company, Archives Library.)

(*left*) Judge Martin P. Joyce graduated from East High School, then earned a degree from Ohio University and, following Army service during World War II, a law degree from Ohio State University. In 1959, he became judge of the Youngstown Municipal Court and judge of the juvenile division of the Mahoning County Common Pleas Court in 1969. (Courtesy of Martin P. Joyce.)

(*right*) Ursuline High School graduate Maureen Cronin became the first woman prosecutor in Youngstown. She graduated from Youngstown State University and later earned a law degree from Akron School of Law. Cronin served a two-year term as Youngstown's Assistant City Law Director and in 2004 is presiding judge of the Mahoning County Common Pleas Court. (Courtesy of the office of Maureen Cronin.)

John Cantwell moved to Youngstown in the 1880s to become an ironworker. He was appointed Youngstown's chief of police in the 1890s and served actively in the AOH and other Irish community organizations. In 1910, he served on the prestigious planning board to build St. Elizabeth's Hospital. (Courtesy of Martha Parry.)

Matt McGowan, a grandson of Irish immigrants, was born in Niles. McGowan began as a roller in the Falcon Steel mill and left to join the Niles police department in 1937, gaining a reputation as a skilled investigator and advancing through the ranks to chief of police in 1948. Through his police work and tireless dedication to helping improve the lives of young people, McGowan became somewhat of a legend. (Courtesy of Sal Marino.)

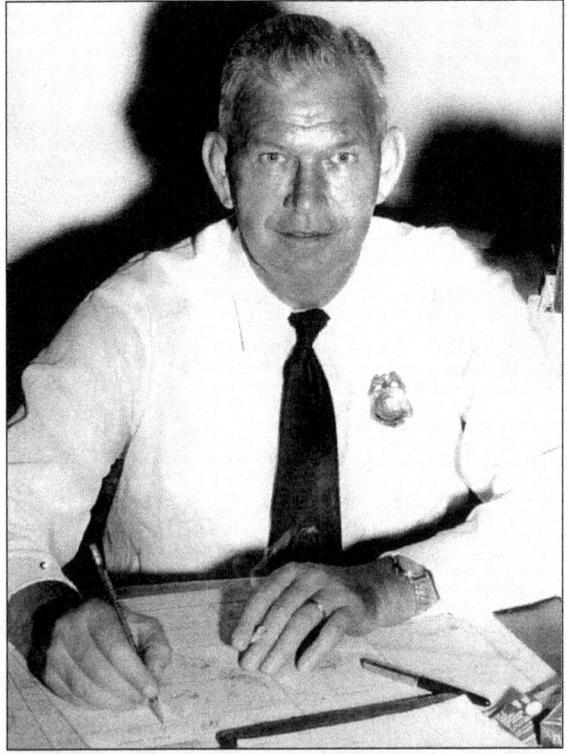

Two-term Youngstown Mayor George M. McKelvey worked in the Youngstown City School system before entering local politics. He is pictured here with his family, left to right, as follows: (back row) Leah, George Jr., Mayor McKelvey, Blake, and granddaughter Claire; and (front row) Sarah, wife Sherry, and Blake's wife Janet. (Courtesy of George M. McKelvey.)

Canfield Mayor Francis McLaughlin, known as "Spike" to locals and "Mac" to his family, grew up in Youngstown and graduated from Hiram College. He coached and taught at Canfield High School and the Mahoning Valley Joint Vocational School before becoming principal at Southeast High School in Portage County. McLaughlin was elected to his first term as Canfield mayor in 1967, a post he held for 26 years. (Courtesy of Sally Murphy Pallante.)

A victim of the September 11, 2001, terrorist attack, Terry Lynch, a 1970 graduate of Ursuline High School, was killed while attending a meeting at the Pentagon in Washington, D.C. Lynch worked as an aide for Senator Richard Shelby and was involved in the activities of a number of Senate committees including intelligence, veterans affairs, Gulf War syndrome, and the commission for weapons of mass destruction. At the time of his death, Lynch was a consultant at Booze, Allen, and Hamilton. He is survived by his wife Jacqueline and two daughters, Tiffany and Ashley. Lynch was a graduate of Youngstown State University where he earned a master's degree in history. (Courtesy of Jackie Lynch.)

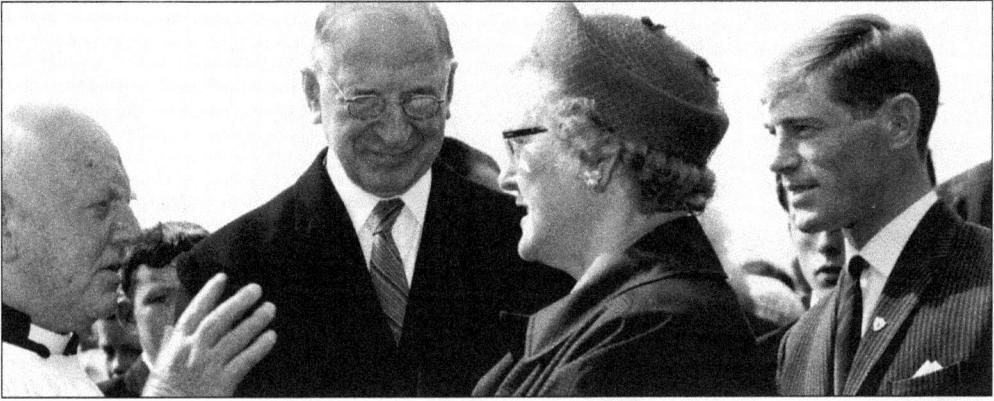

When Sinn Fein came to power in 1918, Eamon DeValera, president of the Irish Republic, came to the U.S. to raise funds and gain support for his new government. The $10 bond certificate shown here was issued to Youngstown resident Mary Lane, and donated by Jack Donnelly to the Irish American Archival Society. Terms of this document promise a return of five percent interest from the first day of the seventh month after the territory of the Republic of Ireland was freed from British Military control. Local resident Mary Ellen Kerrigan O'Hara is seen here in 1960 with Mathew Farrell and a priest, talking to DeValera at Ballintubber Abbey in Ireland. (Photograph courtesy of Dorothy Thornton)

Vincent E.Gilmartin is pictured here at the Gathering of the Irish Clans with his daughter Eileen (local radio personality Casey Malone). He attended St. Brendan's School, graduated from Ursuline High School, and then went on to Harvard University and Ohio Northern University, earning a law degree. Gilmartin served as Ohio's assistant attorney general, as Youngstown's assistant law director, and was elected as Mahoning County prosecuting attorney in 1968, serving two terms until 1984. Well known throughout the Irish community as an active member of the AOH and the Gaelic Society, Gilmartin served for many years on the St. Patrick's Day Parade Committee. He has also been honored by the AOH as Irish Man of the Year. (Courtesy of Sally Murphy Pallante.)

Ursuline High School graduate Rosemary Durkin (pictured on right) was elected clerk of Youngstown Municipal Court in 1975. Revealing her strong ties to the family's Irish heritage, Durkin is a member of the Mahoning Valley chapter of the Irish National Caucus and the Ladies AOH. Rosemary's Mother (left), Bridget Durkin was born in Culmore Swinforn, County Mayo, Ireland, daughter of Patrick and Ann DeVaney. (Courtesy of Rosemary Durkin.)

Honored in 1999 as AOH Irish Man of the Year, Edward Reese is a lifetime Mahoning Valley resident and graduate of Cardinal Mooney High School. He attended Youngstown State University and Bowling Green State University, graduating with honors in the field of gerontology. Pictured with 1994 AOH honoree Michael Patrick Murphy, Reese was first elected Mahoning County commissioner in 1995. Reese serves on the St. Patrick's Day Parade Committee and is a member of the Mahoning Valley Gaelic Society and the AOH. (Courtesy of Sally Murphy Pallante.)

Ｆive

FAMILIES AND
COMMUNITIES

The personal and economic devastation resulting from the Famine years of 1845–49 continued to influence Ireland for succeeding generations. The poverty and landless nature of many led to a gradual change in the structure of Irish families. In the late 1800s, Irish men and women delayed marriage and childbearing until their late 20s or early 30s, and in many cases, chose not to marry at all. These changes brought a new composition and definition to Irish families, actually bringing siblings and extended family members closer together. It was not uncommon for brothers and sisters to make a home together and to include cousins, aunts, and uncles in their extended household. These changes meant that Irish immigration patterns differed from other ethnic groups entering America at the turn of the twentieth century. By 1900, slightly more than half of all Irish immigrants entering America were single women arriving alone.

The experience of Jennie (Jane) McNamara Buckley illustrates the autonomy accorded young Irish women. Her family left Ireland during the Famine years for England. When her 15-year-old brother Harry disappeared after being sent on an errand, the family was quite surprised to hear some months later that he had sailed to America. Thomas and Anna McNamara sent Jane, then only 13, to the United States to find her brother, who was living with an uncle in Sharpsville, Pennsylvania. Jane not only found Harry, but chose to remain in the Mahoning Valley. Following a common pattern for young Irish women, she went to work as a domestic servant in the household of Henry Forker. She eventually married Timothy Buckley, an iron puddler and emigrant from Wales. With the financial backing of the Forker family, Jane built a hotel in Sharon, Pennsylvania. She expanded her real estate holdings to include three hotels and several houses in Sharon, which she and Timothy rented to fellow Irish immigrants, whom they sponsored as citizens.

Similar family patterns emerged among other Mahoning Valley Irish families. Many first generation immigrants married recent arrivals from Ireland and perpetuated traditional values learned in the homeland. Bridget Gibbons came to Youngstown as a young woman in 1884 and within a few years met recent immigrant Thomas J. Flynn, who arrived in 1887. The couple were married at St. Columba's in 1895 and settled on Youngstown's east side where they raised a family. The Flynns lived in the heart of the Youngstown Irish-American neighborhood known as Kilkenny. Here, recent immigrants lived near second and third generation Irish-Americans and formed a close-knit ethnic community that made such marriage matches possible. These customs likewise prevailed in other Valley communities. In 1904, Jack Miller, a Sharon resident originally from Tourmakeady, County Mayo, married recent Limerick immigrant Florence Flynn. The couple raised two sons, and many of their descendants still live in Mercer County, Pennsylvania.

Irish-American families in the Valley shared a vibrant cultural heritage, which has persisted among succeeding generations. Members of the Murphy family from the Kilkenny neighborhood

still remember dinners at their Poland Avenue home with the front door thrown open and cousins, aunts, and uncles carrying tasty Irish dishes to share with the extended family. The continued closeness of Irish families and the ethnic community means that today's generation of Irish-Americans know how to make Irish soda bread and recall family set dances, where the furniture was moved out and the rugs rolled up for a social event that included song, dance, and much merry-making. It also means that they value the importance of a strong work ethic, an active faith life, a commitment to community service, and an abiding love of their family, friends, and their country.

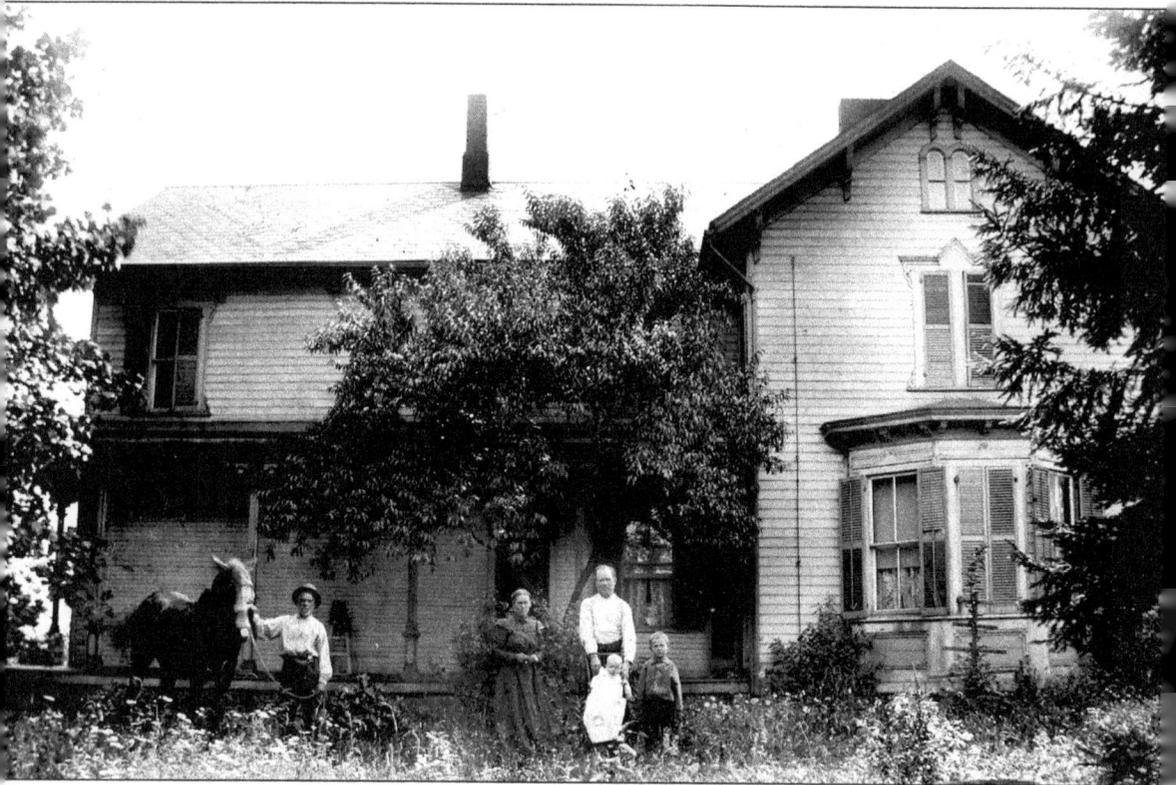

Patrick Kennedy's success in business enabled him to purchase farmland in east Youngstown for his retirement. The long entrance drive from Oak Street crossed bridges and had curves, reminding him of his native Tipperary so he built the Kennedy Homestead here, overlooking Lincoln Park and Kennedy's Springs. One of the most impressive homes on the east side, this stately five-gabled structure was affectionately referred to as the "Irishman's Castle on the Hill." (Courtesy of John Kennedy and Peggy Kennedy Yanek.)

John James "Jack" Miller was a second generation American, the eldest son of Patrick and Anna (Walsh) Miller from Tourmakeady, County Mayo, was born June 12, 1869. He attended Sharon schools and worked at Westinghouse Electric in Sharon, where he was instrumental in organizing the union. In 1904, he married Florence Flynn, then a recent emigrant from Limerick. They had two sons: Albert Francis "Amby" and John James Jr. Miller worked as a bartender and a club manager at the Eagles in Youngstown prior to and during prohibition. On December 3, 1934, he was tragically killed by a hit and run driver as he departed a Youngstown streetcar. (Courtesy of Ted Miller.)

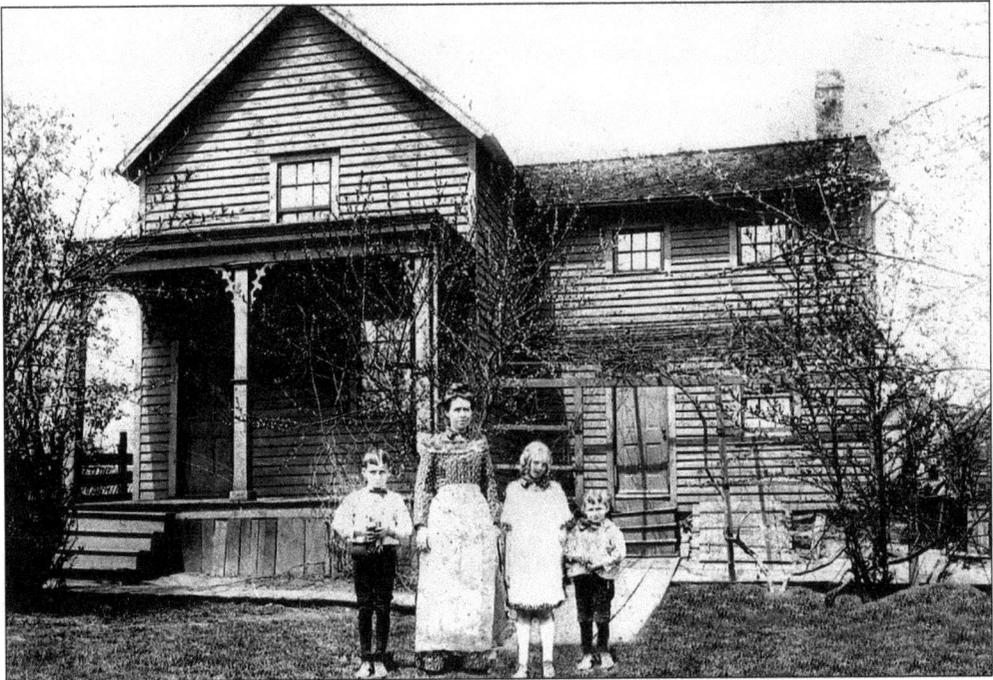

Martin Hughes, born in Ireland, owned a typical working class home in Youngstown's Brier Hill neighborhood. Shown are: (left to right) son Edgar, Martin's wife Mary (Boggins), daughter Lorene, and son Ray. The baby, Joe, is not pictured. Lorene helped to raise her three brothers following their mother's untimely death. Young Ray served in World War I and was active in the local AOH. (Courtesy of Father Richard Murphy and his mother, Martha Whelan Murphy.)

In the summer of 1909, 53 descendants of County Offaly emigrants Peter J. and Margaret Ann Hoey Walsh gathered and are pictured during a family reunion at Lincoln Park (East End Park). Family surnames in addition to Walsh include Sponsler, McLaughlin, Greesley, Gartland, and Rees. (Courtesy of Eileen Walsh Novotny.)

Michael Hourigan moved with his parents, John and Ellen Neagle Hourigan, from County Limerick to Plainfield, Connecticut, in 1850. Hourigan was a prosperous cabinetmaker and a devoted husband to Catherine Monaher Hourigan, who bore him 11 children. Pictured here are: (left to right) Madeline, Ellen, John A. Catherine (mother), Richard, Michael H. (father), and Joseph; standing: (left to right) Florence, Mary, Elizabeth, Michael, Catherine, and James. A grandson, Michael J. Hourigan, who resides in Warren, Ohio, was an active member of the Irish Heritage Society, the Erin Go Bragh Club, and the Blessed Sacrament Church. (Courtesy of Michael James Hourigan.)

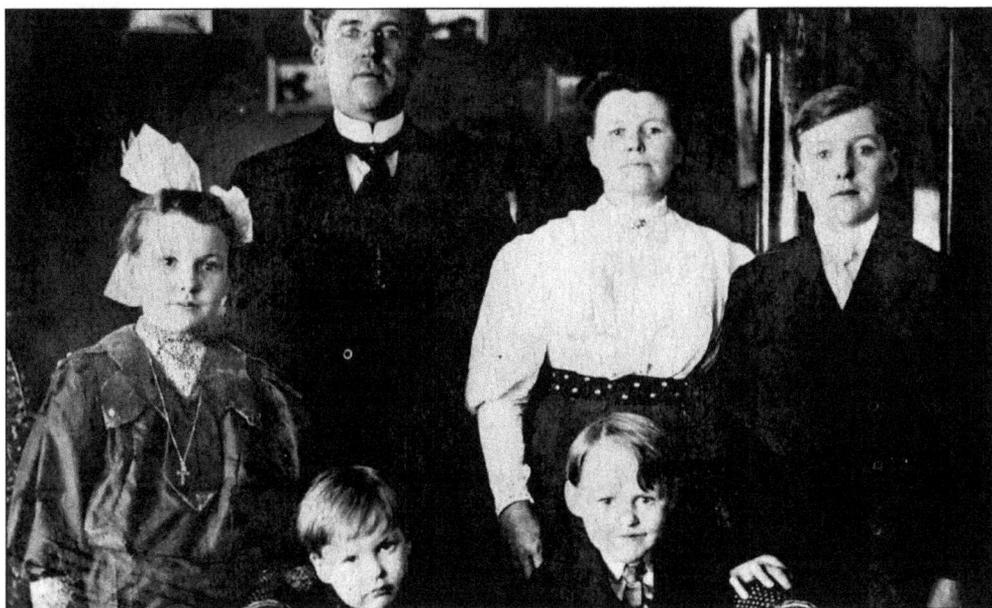

The Burke Apartments on Youngstown's north side were developed in the early 1900s by Peter J. and Mary Ann (Cooney) Burke. They are pictured here in 1905 with children: (left to right) James Aloysious, Mary Gertrude (Dignan), and sons Paul F. and Peter J. Another daughter, Ethel (Howard/Mahoney), was born in 1908. The Burke Apartments, still visible from the Madison Avenue expressway, survived a fire that made *Vindicator* headlines. A member of St. Columba Parish, Mary Ann was one of the founders of Junior Seton Club. Paul Jr., a grandson, an avid art collector, donated an impressive pre-Columbian art collection to the Butler Institute of American Art. (Courtesy of Jane Burke McHugh.)

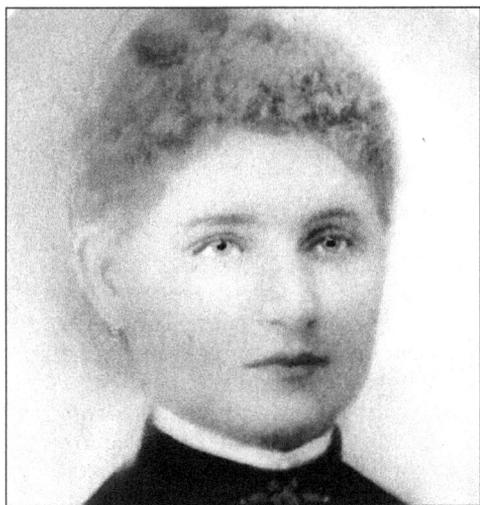

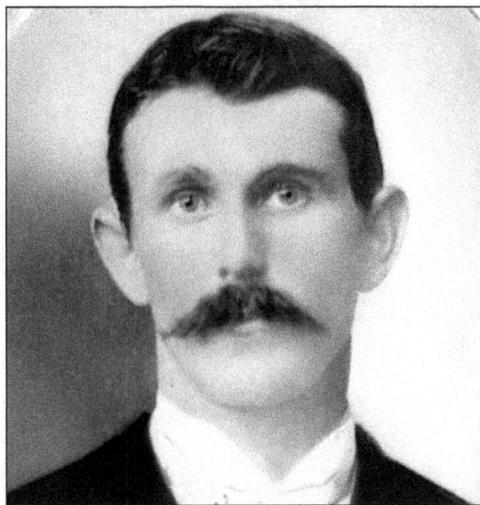

Bridget Gibbons and Thomas J. Flynn emigrated from Ireland to the United States, she in 1884 and he in 1887. Married at St. Columba Church in 1895, the couple first made a home in Pennsylvania then moved to Poland Avenue before finally settling on Youngstown's east side. Blessed with six children, Thomas and Bridget were committed to family values, and Catholic parish life played a prominent role in their lives. Thomas worked as a puddler in the steel mills. (Courtesy of Thomas J. Flynn III.)

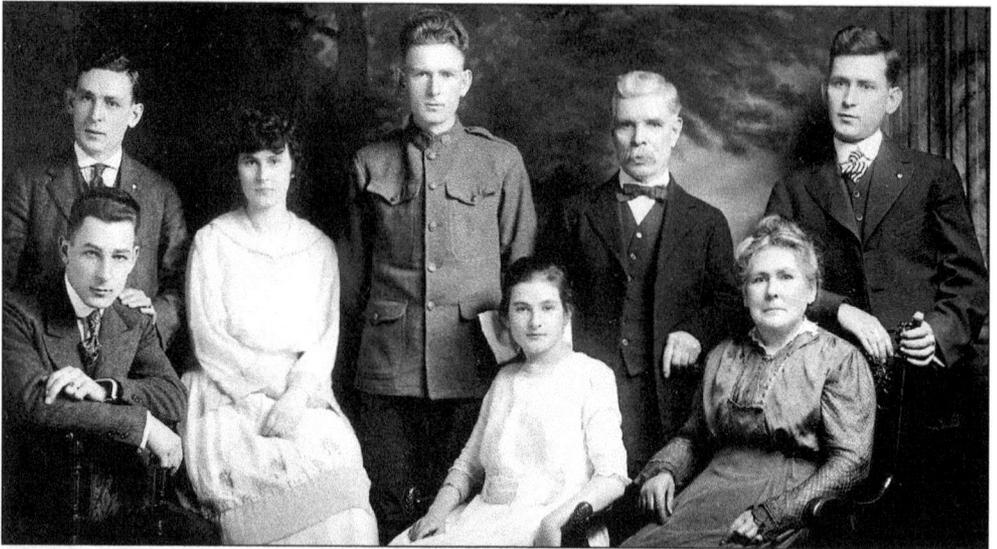

"There was no Famine in Ireland—there was starvation in abundance," according to the Lyden family history. Pictured seated: (left to right) Leo P., Marie J., Cathryn, Mary Josephine Brannigan (Mother, born in Ballinrobe, County Mayo); standing: (left to right) James F, Thomas, Thomas J. (Father), and John M. Lyden. Thomas J. Lyden was a puddler's helper in the steel mills and was so talented that other puddlers sought his advice. All are descendants of Martin and Bridget Lyden who left Ireland in 1853. In 1869, the family emigrated from Scotland and settled in the Brier Hill area of Youngstown. (Courtesy of Karen Lyden Cox, and Clare Anne McCloud.)

In early 1900s formal wedding attire, beautiful bride Frances "Fanny" Quinn (born to Michael T and Frances Burke Quinn) married Garrett Connors. Bridesmaid Mary Columba Fleming (born 1887 to John P. and Bridget "Delia" Burke Fleming in Niles) later married John (Jack) Lyden, a son of Thomas J. Lyden. Bridesmaid Mary Sauce (born in 1880 to John and Bridget Dunn Sauce of Trumbull County), was a close friend. (Courtesy of Louise Quinn Joyce and Karen Cox.)

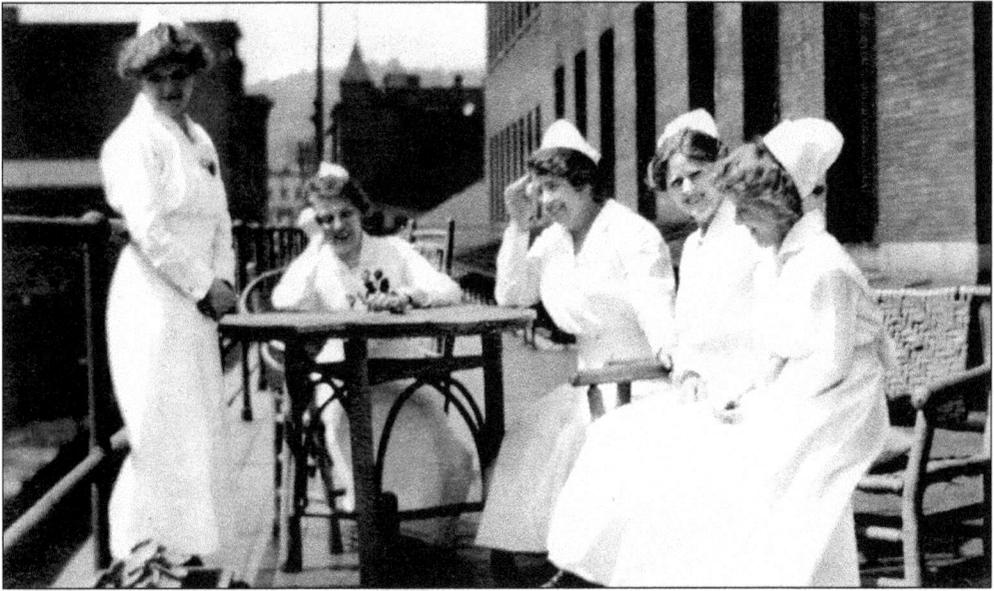

"Suffering calls Nurses to France." Like so many young women of her generation, Irene Dunlea aspired to be a nurse. She trained at Pittsburgh's Allegheny General Hospital and upon graduation, departed New York on her way to Europe during World War I. While caring for the wounded in a French hospital, she met her future husband Leroy Chase. Irene is pictured third from the right in the photograph. (Courtesy of Dr. Fred Dunlea.)

This photograph, snapped at the corner of Charlotte Avenue and Pearl Street on the east side of Youngstown, captures a celebration of America's victory in World War I by the following: (clockwise, left to right) Mrs. Patrick Galvin, Anna Harrison (in nurse's attire), Mary Louise Galvin Ucello (in bonnet), Mary Elizabeth Connors Loftus (headband), Martha Galvin Berkholtz, Billy Cunningham (soldier), and John Regis Reddington (sailor). The driver of the car is Clarence Galvin. (Courtesy of J. Regis Reddington.)

Thomas Patrick Griffin was born in Rosmuck, County Galway, in 1872 and came to America, settling in Struthers to work at Youngstown Sheet and Tube. Thomas and wife Catherine were parents of six children. Left to right, are: Florence, Mary, their mother Catherine, Margaret, and Kathryn. Jim, the oldest born in 1912, is standing next to brothers John and Tom. Following his father to work at Youngstown Sheet and Tube, Jim Griffin broke his back loading the open hearth. Jim read law books while in a body cast and represented himself in court against the Sheet and Tube and won the case. Elected director of the United Steelworkers of America District 26, Jim and national president, I.W. Abel, lobbied locally and in Washington to improve working conditions and benefits. (Courtesy of Ed and Mary Lou Casey.)

This is a special photograph. Someone took time to pose the six children of William P. and Margaret Flanigan Quinn in the back yard of 325 North Garland Avenue on Youngstown's east side. From left to right, are: Robert, age 2; William Jr., age 4; Rita, age 7; Edward, age 8; Raymond, age 10; and James, age 12. (Courtesy of Richard Quinn.)

Three Nalley brothers left Ballinrobe, Ireland, in the 1880s. James went to Rochester, New York, while Patrick and Thomas settled in Youngstown. Patrick J. Nalley (1868–1929) is pictured with his wife, Elizabeth Conroy Fox (right). They were among the founders of Immaculate Conception Church. Son, Joseph T. Nalley (pictured below) was born in 1911, the youngest of the 10 Nalley children. In 1936, he married Margaret Mary Drummond, and together they became parents of five, while Joe toiled 30 years as a steelworker. Before he died in 1979, Joe was active in the AOH, being named the 1976 Irish Man of the Year. In 1980, Division No. 6 honored him, by naming their division "Joseph T. Nalley." (Courtesy of Peggy Nalley McDonough.)

World-renowned comedian Hal Roach, who headlined Dublin's Jury Hotel Irish Cabaret for many years, was the star of the 1976 Irish Show that was produced by Tim Mulholland. Here, Roach is enjoying an after-the-show libation at the old Hilton Tavern, now Irish Bob's Pub, with Scotty Farrell, James McCabe, (Roche), Peanuts Reardon, and Joe Nalley. (Courtesy of Peg Nalley McDonough.)

This photograph was taken at Our Lady of the Elms convent in Akron on the occasion of a relative taking her first vows and receiving the habit of the Dominican Sisters. The four ladies are Mrs. William (Agnes) Timlin, Mrs. Thomas (Mary) Howley, Mrs. Michael (Mary) Durkin, and Mrs. Patrick (Marie O'Connor) Durkin. Marie O'Connor, who was born in Charlestown, County Mayo, married Patrick Durkin and lived on Lucius Avenue. They are the parents of Joan Durkin Ruffing who provided the picture.

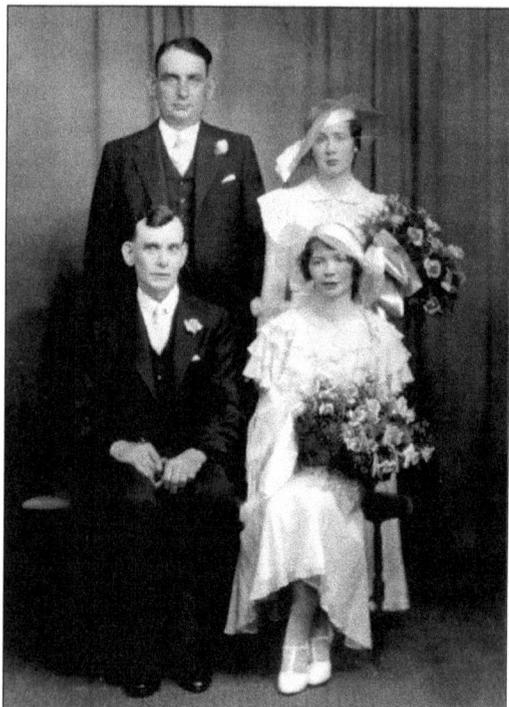

Mary Kate McAndrew Rochford, born in 1904 Cross Molina, County Mayo, the daughter of James McAndrew and Maria Ruddy McAndrew, was baking Irish soda bread, as she does every day, when Regina Welsh recorded an oral history for the Irish American Archival Society in 1997. Born in 1904, she is pictured here with her husband Anthony C. Rochford on their wedding day, July 10, 1934. Standing behind the newlyweds are A.P. O'Horo and Marie McAndrew Fowler, attendants at the St. Edward Church Ceremony. (Courtesy of Regina Welsh and Evelyn Stoops.)

Irish families in the Mahoning Valley have long enjoyed traditional Irish set dances. In many cases, the children remember the family moving the furniture and rolling up the living room rug to make a dance floor as all the neighbors arrived for a family social. Others tell of wedding receptions at home, often planned in summer so the front porch could accommodate additional guests. Family members would recite a "party piece" or play an instrument leading others to join in a favorite tune to which young and old sang and danced. John Carlon came to America in 1920 from Kiltemagh, and Mary Glenn Carlon arrived in 1926 from Tourmakeady. They met in front of St. Columba Church and were later married there. Children James, John, Eugene, Theresa, Noreen, and Kathleen grew up with family parties that included Uncle Dan Carlon playing set dances such as, "Stack of Barley" and "Shoe the Donkey." Francis Murphy's parents were Edward of Ballina, County Mayo, and Margaret McGinty Murphy of County Sligo. After their wedding at Sacred Heart Church on September 20, 1957, Theresa and Francis are pictured at their Arco Club reception. Enjoying a set dance on the left is Miles Ruane and bride Theresa. The groom has the hand of Nora Murphy Howley, next are John Carlon and Margaret Crann. (Courtesy of Theresa Murphy Reardon.)

Marie Barrett was born in Youngstown in 1919, attended St. Patrick's, and graduated from the Rayen School in 1937. In 1941, she received a B.S. in education from YSU. During World War II, the college offered Civilian Pilot Training with Bernard Airport, and Marie enrolled. Following training, she served as one of 1,074 WASPS who completed Air Force training. An Army Air Force veteran of World War II, she flew personnel of the Weathered Wing to bases around the country. Marie and John Marsh were married in St. Edward's Church in 1944. They raised a family of seven children with Marie combining parenting and teaching. Marie died in 1997 and in 1999 was inducted into the Ohio Women's Hall of Fame. (Courtesy of John Marsh.)

Mary Margaret McCann, Grace Haggerty, Ruth Sharres, and Mary McCullion (Murphy) were officers in the Theresan Club of St. Columba Parish in the 1930s. The group's director, Reverend William Dunn, started the Theresians as a spiritual and social association for young women of the parish. Named in honor of St. Theresa of Lisieux, the group sponsored and engaged in a variety of activites. A 1930 Mother-Daughter Banquet for over 200 mothers and daughters featured Miss Francis Wirt singing "My Rosary" and "That Old Irish Mother of Mine." A musical comedy, "His Son's Wife," was presented jointly by the Theresan Club and the Columban Club. (Courtesy of Mary Catherine Alcook.)

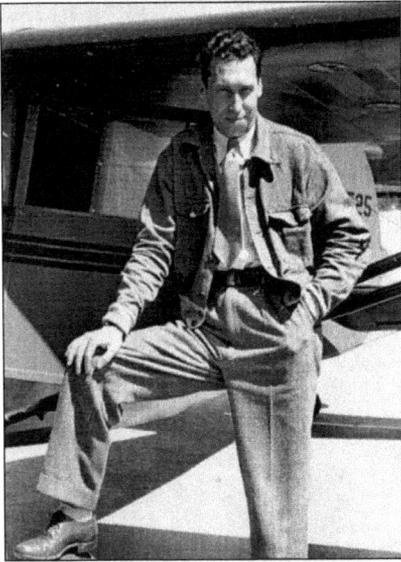

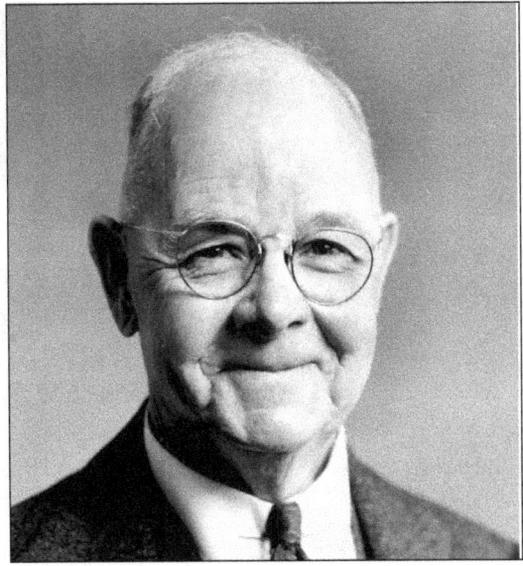

(*left*) John Martin Lyden Jr. is posing in front of an Aeronca trainer. Born in 1916, the son of John M. and Mary Columba Lyden, he made his first solo flight in 1939. Hooked on flying, Lyden gave up his job at Youngstown Sheet and Tube in 1942 to attend navigation school in Annapolis, Maryland, then worked at Beckett Aviation from 1944 to 1981. He retired after 37 years and with over 15,000 flight hours logged in his career. (Courtesy of Karen Lyden Cox.)

(*right*) James Patrick (Peaches) O'Neill, son of William and Ellan Daley O'Neill, was born in Youngstown on July 29, 1876. Retiring as captain on the Youngstown Fire Department in 1944, he saw the advance of horse drawn wagons to modern trucks in 38 years of service. Kevin and John J. O'Neill, Fire Chief of Youngstown are the third generation of O'Neill's on the department. (Courtesy of John J. O'Neill.)

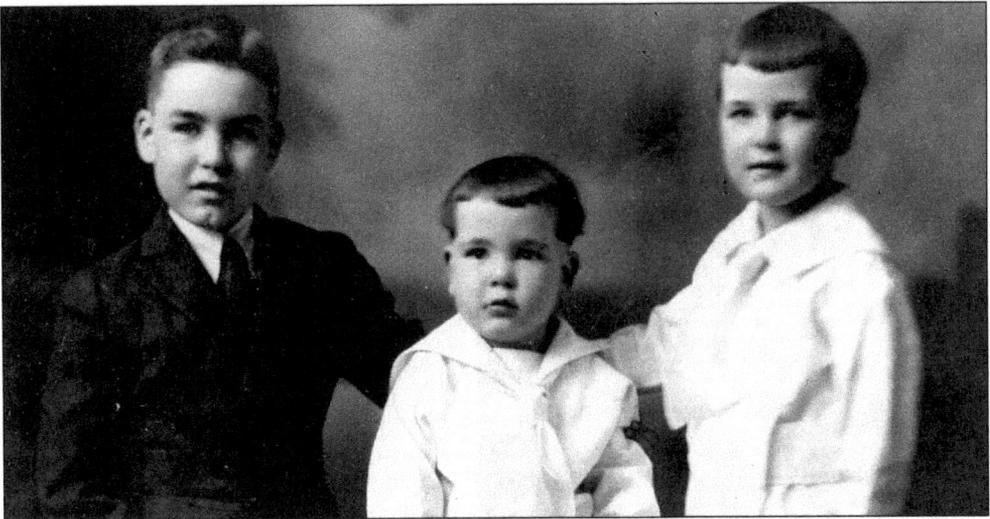

Growing up at 902 Poland Avenue held happy memories for the four surviving sons out of ten children born to Michael and Margaret Cavanaugh Murphy. Their older brother Eugene is not pictured in this 1920 portrait of Regis, Bernard (seated), and Anthony. One of those memories was of daily visits of Grandfather Michael Thomas Murphy, an Irish immigrant who fought in the Civil War, pressing a coin in the little boys' hands as he left. (Courtesy of Sally Murphy Pallante.)

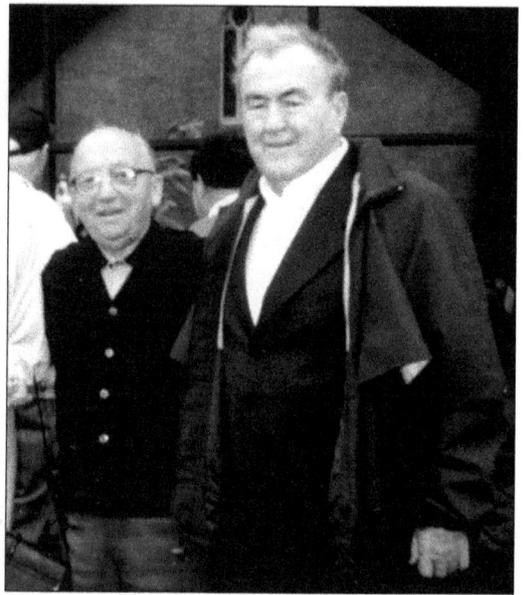

(*left*) Mary Melvin Kerrigan and her son Jim remained in Bonniconlon, County Mayo, while her children Michael, Patrick, Charlie, Anne, Mary, and Catherine immigrated to America. The story of Jim's 1924 secret journey from Ireland several years later at the order of the Mayo Militia of the Irish Republican Army is a family favorite.

(*right*) Father John Lyons and Jim's son, Shamus are at the Shrine of Our Lady of Knock before visiting their ancestral homes. Father Lyons was born in 1921 in Ballyhaunis, County Mayo. Shamus, active in the Youngstown Irish community, served as president of the Gaelic Society and was instrumental in the establishment of the Burke School of Irish Dance. (Courtesy of Jim Kerrigan.)

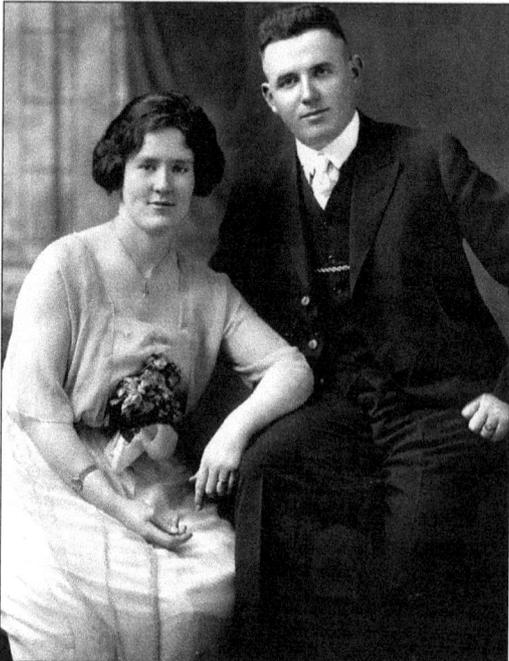

On August 10, 1921, Mary Ellen Kerrigan and Thomas O'Hara were married at St. Columba Church. The bride was born on July 2, 1896, in Ballina, County Mayo, and immigrated to Youngstown in 1914, where she found employment with the Ford family on Wick Avenue. Thomas J. O'Hara was born in 1890 in Culleens, County Sligo, and in 1912, he fortunately missed his passage on the ill-fated *Titanic*. During World War I, O'Hara served in the Army medical corps in France. He later joined the Youngstown Police Department and built a house on Lincoln Park Drive, where the couple raised Loretta, Robert, Raymond, and Dorothy. (Courtesy of Dorothy O'Hara Thornton.)

Although they were both from Ireland, Thomas P. Ring from Freemont, Charleville, County Cork, and Catherine E. Crean from Bonniconlon, Ballina, County Mayo, did not meet until they came to America. Tom left Ireland from Cobh in 1925, first immigrating to Canada, then to Youngstown where he worked as a bus driver. Catherine sailed from Liverpool in 1923 on board the R.M.S. *Carmania*. She was sponsored by her Aunt Bridget McLaughlin Durkin. This wedding photograph from August 28, 1930, is the prized possession of granddaughter Christine Hagman. The Rings lived on Benita Avenue in Youngstown where they raised sons Thomas F., John E., and James J. Ring.

This photograph, taken in front of the family home in Kilkerrin, Ballinasloe, County Galway, is of Mary (Connolly) and Patrick Kelly, proud parents of young Father Thomas and Sister Kieran, a Sister of Mercy. Ordained at All Hallows Seminary in Dublin in 1947, his first assignment was to the Cathedral of Youngstown Diocese. Monsignor Thomas Francis Kelly served as pastor of St. Christine Church from 1973 until his retirement in 1990. Monsignor Kelly was celebrated as AOH Irish Man of the Year in 1984. (Courtesy of IAAS.)

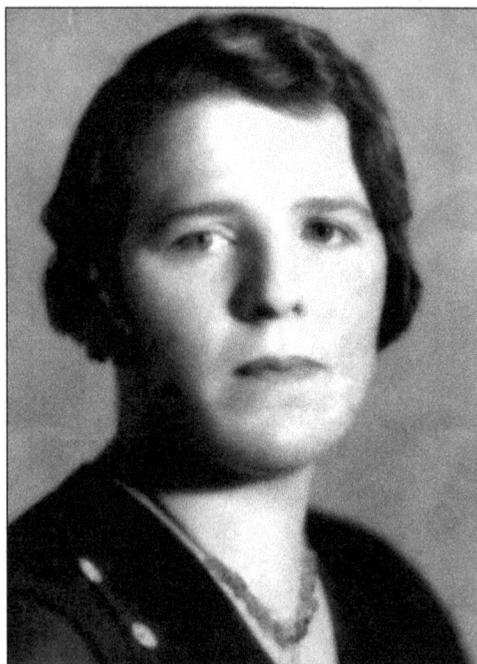

Mary Ellen Coyne, left, and Michael Patrick Lyden Sr. married August 25, 1918, in Tourmakadey, where son John, right, and daughter Ellen (Nellie) were born. Unpredictable crop conditions in Ireland led Michael to immigrate to Youngstown in 1923, where his brother John owned a home on Byron Street. In 1925, five-year-old John and Mary Ellen followed, leaving Baby Nellie with her grandmother Coyne. In 1939, Nellie joined her family in Youngstown. Michael Sr. worked for the Republic Steel Corporation, and the family lived on Craglee Avenue. (Courtesy of Roberta Robinson.)

The Lyden family grew larger in America with the birth of Michael "Yugs" Jr. (pictured at left), Thomas "Babe," and Margaret "Peggy." During World War II, John served in the Air Force as a B-29 flight engineer in the South Pacific. Not to be outdone, brother Michael served in the Army Infantry, receiving the Purple Heart after being wounded in the Battle of the Bulge. The brothers were founding members of the Mahoning Valley Gaelic Society, with both serving as president of the group. John was honored as Gael of the Year in 1987. (Courtesy of Roberta Robinson.)

This image of Canfield's Dr. Jerri Nielsen at the South Pole appeared on the cover of *People Magazine*, November 1, 1999. During this expedition, Dr. Nielsen was the sole medical doctor at the U.S. South Pole Amundsen-Scott station. Adventure turned to nightmare when Dr. Nielsen discovered a tumor in her breast, but could not be evacuated for more than four months because of weather. She performed her own biopsy and then gave herself chemotherapy. The Air National Guard rescued Dr. Nielsen in October, when Major George McAllister and his LC-130 Hercules cargo plane crew made a dangerous landing on a frozen runway. (Courtesy of Phil Cahill and Diana Cahill.)

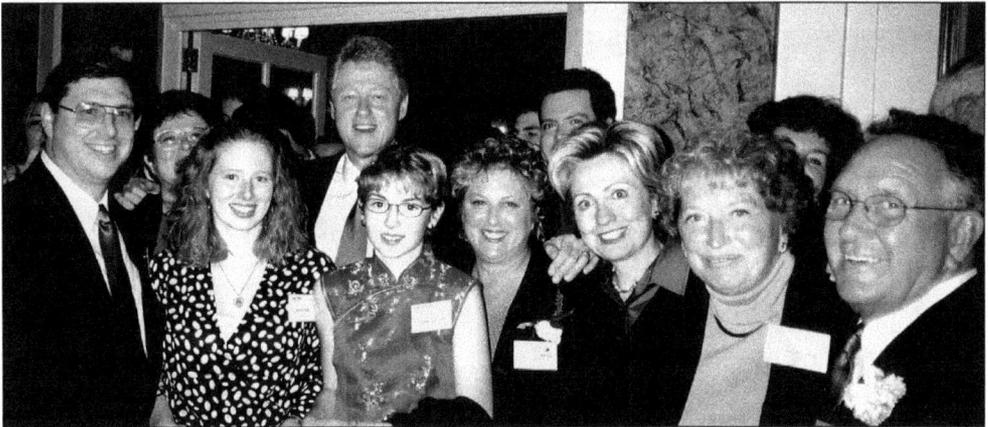

Bill and Hillary Rodham Clinton presented Dr. Jerri Nielsen with the Irish American of the Year award on March 17, 2001, in New York City. Pictured are : (left to right) Eric Cahill (brother), Diana (Eric's wife) is partially hidden behind their two daughters, Laura and Kathleen, Dr. Jerri Nielsen, Hillary Clinton, Jerri's parents Lorine and Phil Cahill (who also live in Canfield), and President Bill Clinton with a hand on Jerri's shoulder. Scott Cahill (brother) is not pictured. Nielsen graduated from West Branch High School then from the Medical College of Ohio in 1977. Her book, *Icebound*, was a New York Times bestseller. (Courtesy of Phil Cahill and Diana Cahill.)

(*left*) Wilbert Bernard McBride (1915–2002) was the son of Archibald McBride, who left Cork Harbor in 1873. Wilbert and his wife Frances had one son, Paul, born in 1940 who is pictured here visiting his dad in 1945 at Camp Robinson. In the late 1980s, Wilbert became interested in rewriting the lyrics to the state song, "Beautiful Ohio." The Ohio legislature adopted the new lyrics, and on November 6, 1989, Wilbert McBride's lyrics became the official state song for Ohio. (Courtesy of Paul McBride.)

(*right*) Once held annually at McGarvey's Yellow Duck Park, the Irish Fest provided a venue to recognize individuals in the Irish community. In 1996, the honored recipients were Terrence Reardon of the Mahoning Valley Gaelic Society and Wallace Dunne of the St. Patrick's Parade committee. (Courtesy of Sally Murphy Pallante.)

"Christmas in Killarney," sponsored by Muintir na h'Eiréann, "People of Ireland," drew large crowds of Christmas shoppers to the Pilgrim Collegiate Church to purchase Irish goods. Members of the 1999 committee displaying merchandise are Patricia Laing, David and Mary El'Hatton, Sally Pallante, and Christine Crogan. (Courtesy of Dick Coughlin.)

94

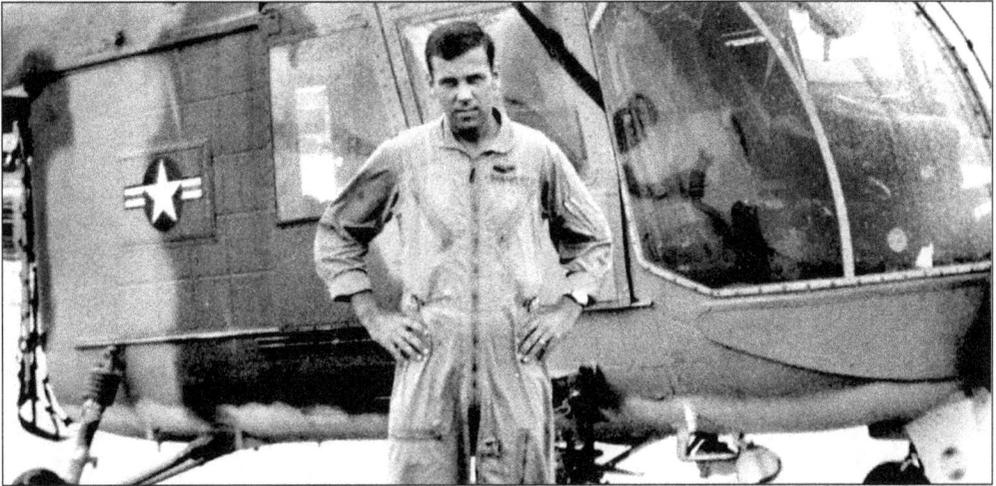

Jim Brahney was born and raised on the east side of Youngstown. In his Air Force flying career, Jim qualified to fly 23 types of aircraft, including jets, props, and helicopters. As a test pilot, he established several firsts in aviation. He is pictured with his rescue helicopter in Vietnam where he and his Irish crew were credited with saving nine lives. (Courtesy of Jim Brahney.)

(*left*) James Kernan was born in Youngstown in 1936, one of eight children of Thomas and Ethel Kernan. In 1954, he received a congressional appointment to the U.S. Military Academy at West Point. During a lengthy military career, he advised the Vietnamese Army, earned a master's degree in Chemistry, taught at the USMA, and commanded the Hawk Missile Battalion in Germany, achieving the rank of Colonel. (Courtesy of Jerry Kernan.)

(*right*) Thomas and Mary Sheridan Casey, married on July 18, 1928, at St. Columba, are pictured here on their 50th wedding anniversary. Thomas and Mary immigrated to Youngstown from County Mayo in the 1920s, where Thomas found employment in the steel mills and Mary as a domestic in a fine home. (Courtesy of Bob Casey.)

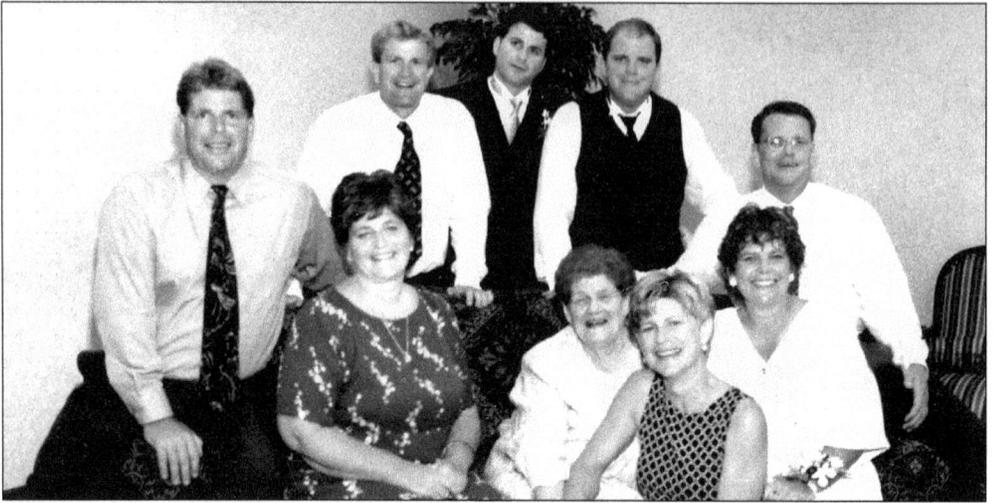

Maureen Collins, local entertainer and co-founder of Easy Street Productions, is pictured here at her brother Gary's wedding. Pictured are: (left to right) Colleen Boyle, Virginia Collins, Kathy O'Neill, Maureen Collins, Mike, Ray, Gary, Doug, and Tom Collins. (Courtesy of Virginia Collins and Debbie Golec, "Moments to Remember," used with permission.)

(*left*) Handsome John Lew Quinn was best known for his vaudeville performances and as a dancer. Lew, born in 1883, to John "Pap" and Margaret Quinn, grew up on Youngstown's east side. In vaudeville and at the Schubert, Lew worked with Marie Dressler, Al Jolson, Eddy Foy, George M. Cohen, and George Raft. (Courtesy of Richard Quinn.)

(*right*) Ursuline High and John Carroll University graduate Patrick Manning is pursuing a master's degree in Irish Studies at the National University of Ireland, Galway. Patrick's interest in Ireland is shared by his grandfather, John P. Manning, whose father, Michael O'Manion, was born near Galway Bay, and whose mother, Mary Gilmore, was born in Ruben, County Mayo. In 1998, John Manning took Patrick and 35 family members to visit Ireland. (Courtesy of Alice Manning and John P. Manning.)

Six

RECREATION AND ENTERTAINMENT

Hard-working Irish families in the Mahoning Valley looked to their communities to balance their employment and domestic responsibilities with relaxation and leisure activities. Among the most popular forms of entertainment were organized sports and amusement parks. The connections made possible by 59 miles of trolley lines in Mahoning County alone, allowed many working-class Valley residents without automobiles to take the entire family on an outing by the 1920s. Baseball parks, football games, boxing matches, dance halls, and parks developed along the trolley and local rail lines, providing many options for an evening's entertainment.

Built as a trolley park by the Youngstown Park and Falls Street Railway Company and open in 1899, Idora Park was a popular destination. As early as 1910, the park's dance hall was the site of many Irish Day celebrations and Gaelic Society dances. In addition to picnicking and dance facilities, Idora Park boasted rides and roller coasters, such as the Firefly and the Rapids, a boat ride that aimed to amuse and frighten riders. Craig Beach on Lake Milton formed another popular spot for amusements, including swimming, picnicking, a dance hall, amusement rides, and a penny arcade.

Family gatherings were held at Idora Park and Craig Beach, but sports became the passion of Mahoning Valley residents, Irish-Americans included. Organized in 1911 by Father Charles A. Martin of St. Patrick's in Youngstown, the Patrician Club supported the sporting activities of south side youth, including both basketball and football teams. The 1915 Patricians' team won a world championship and is memorialized in the Pro Football Hall of Fame at Canton, Ohio. Quite a few nationally known Irish-American athletes received their early training and education at Valley parochial and public schools. Among these are James Farragher, early head football coach at the University of Notre Dame; Paul McGuire, who played pro football with the San Diego Chargers and the Buffalo Bills; and more recently, Bob Stoops, head football coach at the University of Oklahoma in 2004. The Valley Irish have also produced a few important names in the boxing world including, George "Irish Sonny" Horne of Niles, who fought such great welterweights as Rocky Graziano; and Mahoning County Commissioner Tom Carney Sr., who for many years directed the Youngstown Golden Gloves tournament.

Mahoning Valley Irish-Americans also possess considerable talent in the world of popular entertainment. Gene Murphy, a native of Youngstown's Kilkenny neighborhood, was a renowned Irish tenor who delighted regional listeners with a weekly radio show on Pittsburgh's WCAE. Irish-American performers from the Valley have also succeeded in the national and international entertainment world. Among these are actors Joe Flynn, beloved for his role in the television comedy *McHale's Navy*, and Youngstown native Ed O'Neill, known to the world as Al Bundy in the hit comedy series *Married With Children*. Folk singer Maureen McGovern, of "The Morning After" and "Can You Read My Mind" fame, got her start in the coffee houses that surrounded Youngstown State University in the late 1960s.

A tradition of Irish music and dance persists in the Mahoning Valley in the early twenty-first century. The Clancy Brothers are widely credited with reviving interest in popular Irish music in the 1950s, and their influence remains strong in the Valley. Among the popular Irish musical groups in the region are County Mayo, which performs widely in Ohio and Pennsylvania, and has recorded several albums for international distribution. Other groups that perform frequently at local festivals and events include Lou Rafferty and Company, the Mill Creek Ramblers, and Brady's Leap, a group of Youngstown State English professors who interpret traditional ballad in bardic style. Many Irish-American Valley youths perpetuate the tradition of Irish step dance, participating in local, regional, and even international competitions. The tradition is enhanced by the dedication of Tessie Burke, who has taught weekly dance classes for Valley youth for more than 40 years.

Idora Park was a centerpiece of the Valley's recreation, entertainment, and sports scene. The original Dance Hall opened in 1910 and was the site of many Youngstown "Irish Day Celebrations and Gaelic Society Dances." The park played an integral role in the lives of area Irish families and is well remembered as an important part of the legacy of the Valley. (Courtesy of Sally Murphy Pallante.)

James Farragher, a Youngstown native, was head football coach at the University of Notre Dame in 1902–1903, compiling a record of 14 wins, four losses, and two ties. As a player there, he won monograms in 1901 and 1902. Following graduation, he was named the head coach. Farragher remained at Notre Dame where he made his home on campus and was employed in the Rockne Memorial Field House. (Courtesy of the University of Notre Dame Archives.)

Bob Dove, a South High graduate, earned All-American honors on the University of Notre Dame's 1941 and 1942 squads and was named the nation's outstanding lineman in 1942. After spending eight years in the pros, Dove coached for many years at the professional and collegiate level. Many of those years were spent at YSU. He is a member of the College Football, Youngstown State, and Curbstone Coaches halls of fame. (Courtesy of the University of Notre Dame Archives.)

Edward Vincent "Ted" Buckley (first row, far left) was the second Catholic ever to attend Westminster and was captain of the 1912 football team. A versatile athlete and exceptional student, Buckley also lettered in basketball and graduated from the Pennsylvania School of Law. A well-known trial lawyer in Pittsburgh and Sharon, Buckley was very active in Mercer County community activities. Buckley, whose surname comes from the Irish word "Bouchal," meaning "boy," traced his ancestral roots back to County Cork. (Courtesy of Ted Miller.)

The 1921 Columbans were one of the area's most formidable basketball teams. Members of that unit were: (first row, left to right) J. Davis, Marshall, Amrine, and J. Lehnard; standing: Gene Murphy, Hites, and Kotheimer. The Columban Club was not confined to athletics but participated in a variety of activities with St. Columba's Theresan Club.(Courtesy of Kathleen Murphy Shutrump.)

A good friend of all his south side neighbors and an ardent supporter of sports, Father Charles A. Martin, the first pastor of St. Patrick's, organized the Patricians for the recreational enjoyment of the parish's boys. While the Patricians are best remembered for the 1915 World Championship team that is memorialized in the Pro Football Hall of Fame, they produced great basketball teams as well. Former Mahoning County Commissioner Tom Carney Sr. (top row, first man on left, above) was a standout on the 1917 team. William P. Dunlea, the father of local physician, Fred Dunlea Sr. (second row, standing at the far left, below) was a luminary on the 1920 squad. (Above, courtesy of Mary Ann Creatore; below, courtesy of Fred Dunlea M.D.)

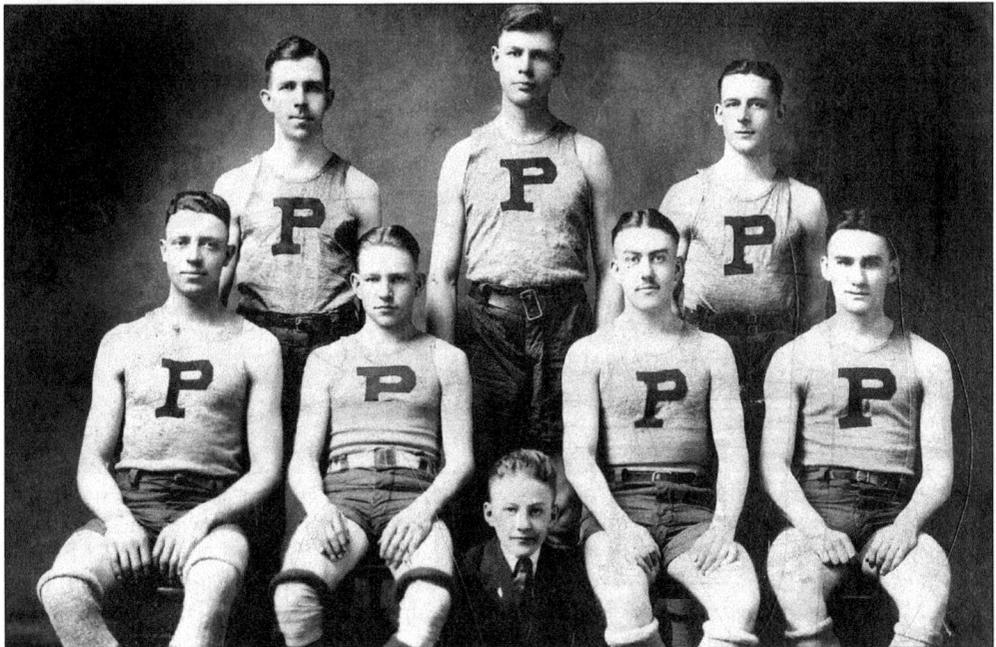

Tom Carey, Ursuline High School coach and educator and member of the Ohio High School Football Coaches Hall of Fame, compiled an impressive record of 100 wins, 53 losses, and 8 ties during his career on Wick Ave. Carey, who became Ursuline's principal in 1972, once said, "You use sports as a classroom for teaching. Good results are not measured only by wins and losses but by the quality of the character in the individuals that were produced." (Courtesy of Ursuline High School.)

Paul Maguire, 1956 Ursuline graduate and one of Coach Carey's greatest athletes, went on to a sterling collegiate career at the Citadel. Maguire played professional football with the San Diego Chargers and the Buffalo Bills and is recognized in the Ursuline, South Carolina, and Buffalo Bills halls of fame. In 2004, Maguire is an ESPN analyst, featured on the Sunday evening NFL game. Maguire established the Nick Johnson Scholarship at Ursuline that makes it possible for many deserving youths to attend his alma mater. (Courtesy of Ursuline High School.)

(*left*) Denny Barrett is credited by many as being the foundation upon which Cardinal Mooney High School's rich football tradition is built. Barrett, who learned the game at the knee of his father, Dick Barrett Sr., the legendary East High coach, established the winning tradition at Mooney that is recognized nationally. (Courtesy Cardinal Mooney High School.)

(*right*) Ron Stoops was a man who gave real meaning to the words excellence, commitment, model, teacher, coach, and family man. A 29-year faculty member at Mooney, he enjoyed great success as the defensive coordinator and the baseball and tennis coach. (Courtesy of Evelyn Stoops.)

Bob Stoops (standing center, signaling "No. 1") and his family are seen celebrating his 2000 University of Oklahoma team's national championship. An All-Steel Valley performer at Mooney, Stoops won All Big Ten and All-American honors at the University of Iowa. (Courtesy of Evelyn Stoops.)

(*left*) Frank Beck won All City football and basketball honors at Ursuline where he was an inaugural member of the school's Athletic Hall of Fame. Many locals still remember Beck's exceptional performance as he quarterbacked YSU to an impressive upset victory over Great Lakes in 1954. Beck returned to Ursuline in the early 1980s and led the Irish to more than 300 wins on the hardwood. (Courtesy of Ursuline High School.)

(*right*) George "Irish Sonny" Horne of Niles fought virtually all of the great welter and middleweights of the 1940s and 1950s, including Kid Gavilan and Rocky Graziano. Early in his career, Horne was trained and managed by Niles police chief Matt McGowan. (Courtesy Sal Marino and Eastside Boxing.)

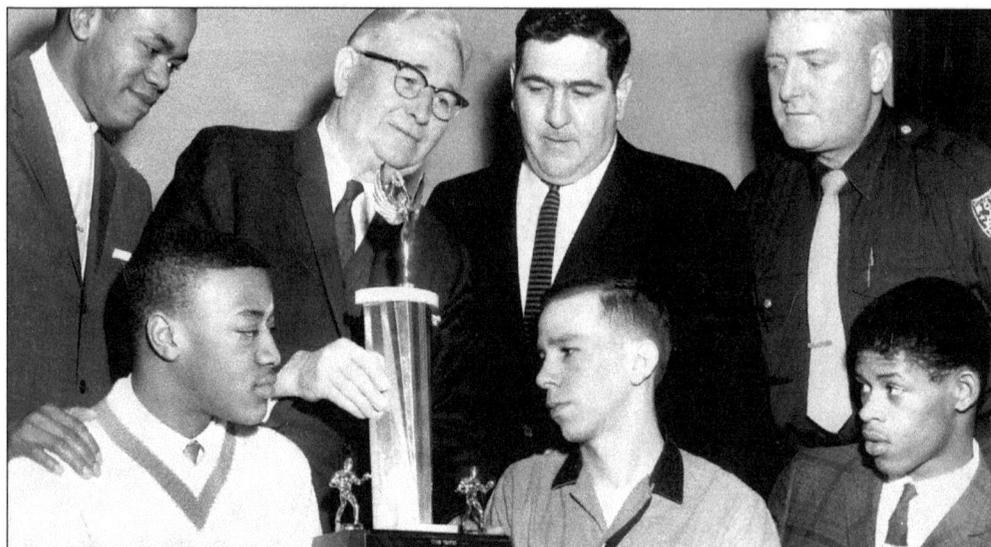

Tom Carney Sr. (top row, second from left), the son of Michael and Mary Conroy Carney of Corr-na-mona, County Galway, is seen awarding a trophy to some of the 1962 Golden Gloves champions. Carney, nationally known and a respected boxing figure, was the director of the Youngstown Golden Gloves tournament from 1927 through the early 1960s. (Photograph by Paul Schell, courtesy of Tom Carney Jr.)

Ed O'Neill, speaking at an Ursuline student assembly, is a talented dramatic and comedic actor who has convincingly portrayed everyone from Popeye Doyle to Al Bundy. He most recently starred as Joe Friday in *L.A. Dragnet*. Ed credits his role in the Ursuline High play, "The Three Wiseguys" that was produced and directed by Sister Rosemary Deibel and written by Monsignor Glenn Holdbrook with spawning his interest in acting. (Courtesy of Ursuline High School.)

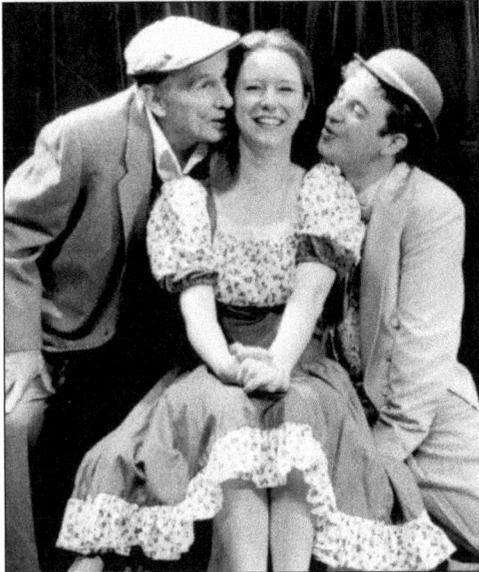

(*left*) Hugh Fagan, pictured on the left in a scene from the 1999 Youngstown Playhouse production of "Finian's Rainbow," appeared in more than 200 productions in the Valley. He and his wife also produced several plays at the Youth Theatre of the Playhouse. (Photograph by Paul Schell, courtesy of Patricia Moran Fagan.)

(*right*) Gene Murphy, born and reared in the Kilkenny section of Youngstown and shown on the far right with his accompanist Billy Walsh, was a renowned Irish tenor who recorded on Victor and Gennet records and appeared regularly on the Keith circuit with Rudy Vallee. (Courtesy of Kathleen Murphy Shutrump.)

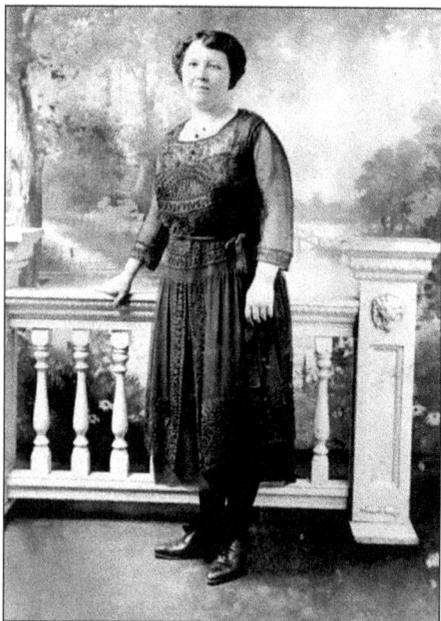

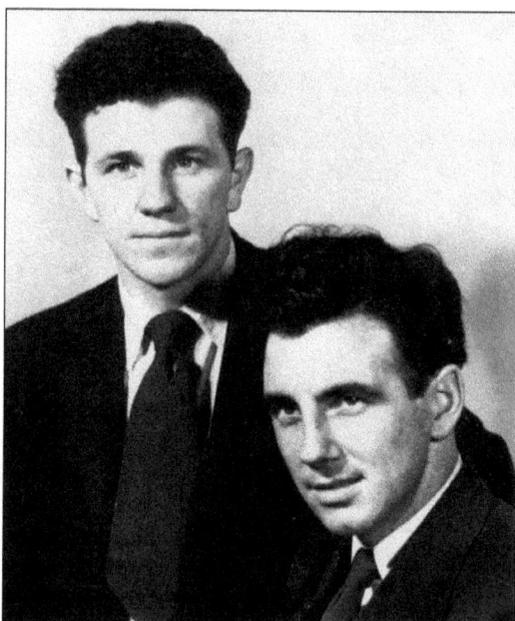

(*left*) Kitty Gillespie, the aunt of the world famous Clancy Brothers, immigrated to Cleveland from her native County Tipperary around the turn of the century and played a significant role in the brothers' illustrious career. (Courtesy of Kitty's granddaughter, Sheila Dunn.)

(*right*) Paddy and Tom Clancy, the first of the brothers to come to America, appear here shortly after arriving in the states under Kitty Gillespie's sponsorship. This one-of-a-kind photograph was supplied to Sheila Dunn of Canfield expressly for use in this book by Mary Clancy, the widow of Paddy Clancy (1922–1998), who lives in Ireland.

The Clancy Brothers, Tom, Pat, and Liam, credited by many with reviving interest in traditional Irish music, came to America in the 1950s. The brothers settled in New York where they joined forces with fellow Irishman Tommy Makem (right, above). After appearing on the Ed Sullivan Show, the Clancy Brothers and Tommy Makem soon became one the most popular groups in the states. (Text Terry Dunn, photograph courtesy of Mary Clancy.)

(*left*) Joe Flynn, a beloved character actor, began his career at the Youngstown Playhouse. His breakout role was that of Captain Wallace Binghamtom on the *McHale's Navy* television series. He later starred in several comedic movies for Disney Studios. (Publicity photograph.)

(*right*) Maureen McGovern was a folksinger in coffeehouses near Youngstown State University in the late 1960s. In the 1970s, her Oscar winning hit songs, "The Morning After" and "Can You Read My Mind," propelled her to national attention. (Publicity photograph used with permission.)

County Mayo, comprised of (left to right) Bill Lewis, Ted Miller, Fred Bishop, Marcy Meiers, and Bill Davis, is a highly talented musical group dedicated to preserving Irish culture. While they perform primarily in the Tri-State area, their Irish ballads featuring Miller's rich baritone voice are heard on radio stations around the world. (Courtesy of Ted Miller.)

(*left*) Lou Rafferty (first row, on right) started playing Irish ballads when he joined McNamara's Other Band. Along with Dave Kennedy and the late Bernie Theiss, he started the group, Blackthorn. The group changed their name to Lou Rafferty and Company and is currently made up of Rafferty, Kennedy, Mark Pringle, and Alan Purdon. (Courtesy of Lou Rafferty.)

(*right*) Brendan and Judith Foley Minogue made their musical debut as Rhyme and Reason in 1982. Since then, they have expanded their group to include Bill Lewis and Barry Robbins and changed the name to the Mill Creek Ramblers. They often perform Irish ballads, old time music, and original compositions. (Courtesy of Brendan Minogue.)

In the best bardic tradition, four poet/musicians from the YSU English Department joined together first as Shillalelagh Law and now perform as Brady's Leap to present their excellent interpretation of traditional ballads. Shown here are (left to right) a guest mandolinist, William Greenway, Kelly Bancroft, Steve Reese, and Phil Brady. (Courtesy of Ted Miller.)

Mike Shaffer, pictured here with his daughter Theresa c. 1980, is a founding member of the Seanachies. He is a widely acclaimed accordionist who plays at Feisaina throughout the United States, Australia, and Ireland. He also plays regularly for the Youngstown Area Step Dancers and the popular Shaffer Brothers Band. (Courtesy of Bill Lewis.)

The BogTrotters are: (left to right) Mike O'Malley, Nancy Polite, Bob Savage, and Barry Robbins (not pictured), were the first group to bring traditional Irish ballads to the area in the late 1970s and early 1980s. (Courtesy of Nan O'Malley.)

Theresa Burke, here with novice dancer Rachel Kepley, is an internationally heralded Irish step dancing instructor who has been teaching Youngstown youth the art and discipline of step dancing for more than 40 years. Traveling weekly from her home in Elyria, Ohio, Tessie's dedication to Valley children and her profession are evidenced by her many national and international champions. (Courtesy of Sally Murphy Pallante.)

Burke Youngstown School of Irish Step Dancing Class of 1972 included: (front row, left to right) Audrey Cianciolo, Kathy Kerrigan, Mary Murphy, and Katy Lyden; (middle) Kevin Hunter, Carolyn Coughlin, Eileen Gilmartin, and Kevin Murphy; (back) Yvonne Brennan, Kathy Murphy, Amy Coughlin, Noreen Burke, and Mary Theresa Kerrigan. (Courtesy of Tessie Burke.)

Burke Youngstown School of Irish Step Dancing 2003 Oireachtas Team members were: (front row, left to right) Breanne Donoghue, Natalie Super, *Lauren Kepley*, Laurel Wilson, Maura Bobby, *Meghan McCarthy*, and Lindsay Nalepa; (middle) Kiersten Rader, Emily Mogg, Julianne Matthews, Anna Bobby, Brigid Trewella, *Colleen Kratofil*, and Madeline Wilson; and (back) *Ashling Trewella*, Kristie Griffith, *Caitlin Murphy*, *Brendan Trewella*, Megan Ault, Chelsea Blank, and *Molly Trewella*. Kiley Matthews not pictured. Italicized dancers competed at the 2004 World Championship of Irish Dance. (Courtesy of Sally Murphy Pallante.)

(*left*) Brendan Trewella and Jessica Crogan are seen holding trophies won at the 1999 Pittsburgh Oireachtas. Trewella at the left, a nine-time qualifier for the World Championships, is the 2003 Mid-West Champion and is ranked 5th in North America and 7th in the world. Crogan is a three time Mid-West Champion.

(*right*) Caitlin Murphy, has successfully competed on the championship level in the All Irelands, The British Nationals, North American, and World Championship of Irish Dance. In 2004, she placed 14th which was the first American placement and second in all of North America at the "All Irelands." (Courtesy Karen Murphy.)

Craig Beach, a popular amusement park, was located on the shores of Lake Milton. The park began as a popular spot from which picnickers could watch the construction progress on the man-made Lake Milton. Ward Craig's fledgling enterprise expanded to include a dance hall, amusement rides, and a penny arcade. (Courtesy of Lake County, IL Discovery Museum, CurtTeish Postcard Archives.)

(*left*) Ward Craig of Glasglough, County Monahan, roots was a gifted amateur musician who parlayed his property and talents into Craig Beach Amusement Park. (Courtesy of Marilyn Jane Herst.)

(*right*) The Idora Park ferris wheel rose high above the Fosterville skyline announcing to all who could see it that the joys, delights, and excitement of a visit to the world famous park were nearby. Jim Dunn of Canfield, an officer of the Irish American Archival Society and the editor of its quarterly newsletter, *The Harp*, is a passenger in this photograph. (Courtesy of Jim Dunn.)

Pat Duffy Jr. served as president of Idora from 1966. Duffy succeeded his father, Pat Sr. who began working at the park in 1905 and was president from 1949 to 1966. A true Irish bachelor until the age of 41, Pat Duffy Sr. married Catherine Cannon in 1920. Pat Jr., maintaining his Irish heritage, married Marcella Ann Daugherty whose family emigrated from County Mayo. A third generation of Duffys, including Patrick III, Michael, Kathleen, and Eileen Erin, all worked at the park until its closing in 1984. The Duffy family was synonymous with Idora Park and through it contributed greatly to the legacy of the Irish to the Mahoning Valley. (Courtesy of Eileen Erin Duffy.)

\mathscr{S}even

ORGANIZATIONS
AND CULTURE

Irish-American involvement in cultural, fraternal, and benevolent organizations in the Mahoning Valley is another way that the group strives to promote and perpetuate its ethnic heritage in the region and to pass cultural traditions on to succeeding generations of Valley Irish. Some organizations, such as the various local chapters of the Ancient Order of Hibernians, are part of a national network of Irish cultural preservation and connection with the homeland. Others, such as the Irish American Archival Society (this book's author), are locally based and focus more closely on preserving Irish traditions in the Mahoning Valley. Whether nationally connected or locally tied, Irish organizations function to connect individuals of Irish heritage and to celebrate all things Irish.

With numerous chapters throughout the United States, the Ancient Order of Hibernians (AOH) is the oldest Irish-Catholic lay organization in America. It was formed in New York in 1836 as an extension of an Irish organization that defended Gaelic values and protected the Roman Catholic clergy who came under attack during the Protestant Reformation of the 1500s. In mid-nineteenth century America, the AOH aimed to protect Irish immigrants and clergy from attacks perpetrated by nativist-minded Americans who saw the rapid influx of Irish as a threat to their cultural and economic well-being. The motto of the modern AOH, "Friendship, Unity, and Christian Charity," most clearly defines the Valley chapters of the organization. The AOH was operational in Youngstown by the late 1800s and in 1909 opened new headquarters in the Diamond Block, next to the Mahoning National Bank building. AOH activities over the years have included an annual Field Meet and Basket Picnic, St. Patrick's Day and Christmas celebrations, and regular annual meetings recognizing a chapter Irish Man of the Year. The AOH chapters include a women's auxiliary group, the Ladies Ancient Order of Hibernians, which sponsors many area activities within the Irish community, including annually honoring an Irish Woman of the Year.

Besides the Valley AOH chapters, Irish-Americans are involved in groups such as the Knights of Columbus, Muintir na h'Eiréann and the Mahoning Valley Gaelic Society, which aims to promote a knowledge and appreciation of Irish culture. Similar motives propelled the membership of the Irish Heritage Society, which focused on sharing and preserving the history, arts, and humanities of Ireland and the Irish people. Many of these organizations can be found celebrating their Irish heritage in Valley St. Patrick's Day parades and cultural events, such as the Festival of Nations held annually at Youngstown State University.

Beyond St. Patrick's Day celebrations across the Mahoning Valley, the largest organizational event in the Irish community is the Gathering of the Irish Clans. This summer-time event brings together a cooperative of Valley organizations to celebrate a day of Irish heritage and appreciation. Another annual event, the Mahoning Valley Ulster Project, brings a direct connection with the homeland. Beginning in 1986, each July the Ulster Project brings six Protestant and six Catholic teens from Northern Ireland to the Valley where they are hosted by

a teen of the same gender and religion. The aim of this cross-cultural experience is to develop friendships and understanding while breaking down barriers of intolerance. These events and the continuing growth in organizations such as the AOH and the Burke school of Irish dance demonstrate that Irish culture and heritage will continue to thrive in the Mahoning Valley for succeeding generations.

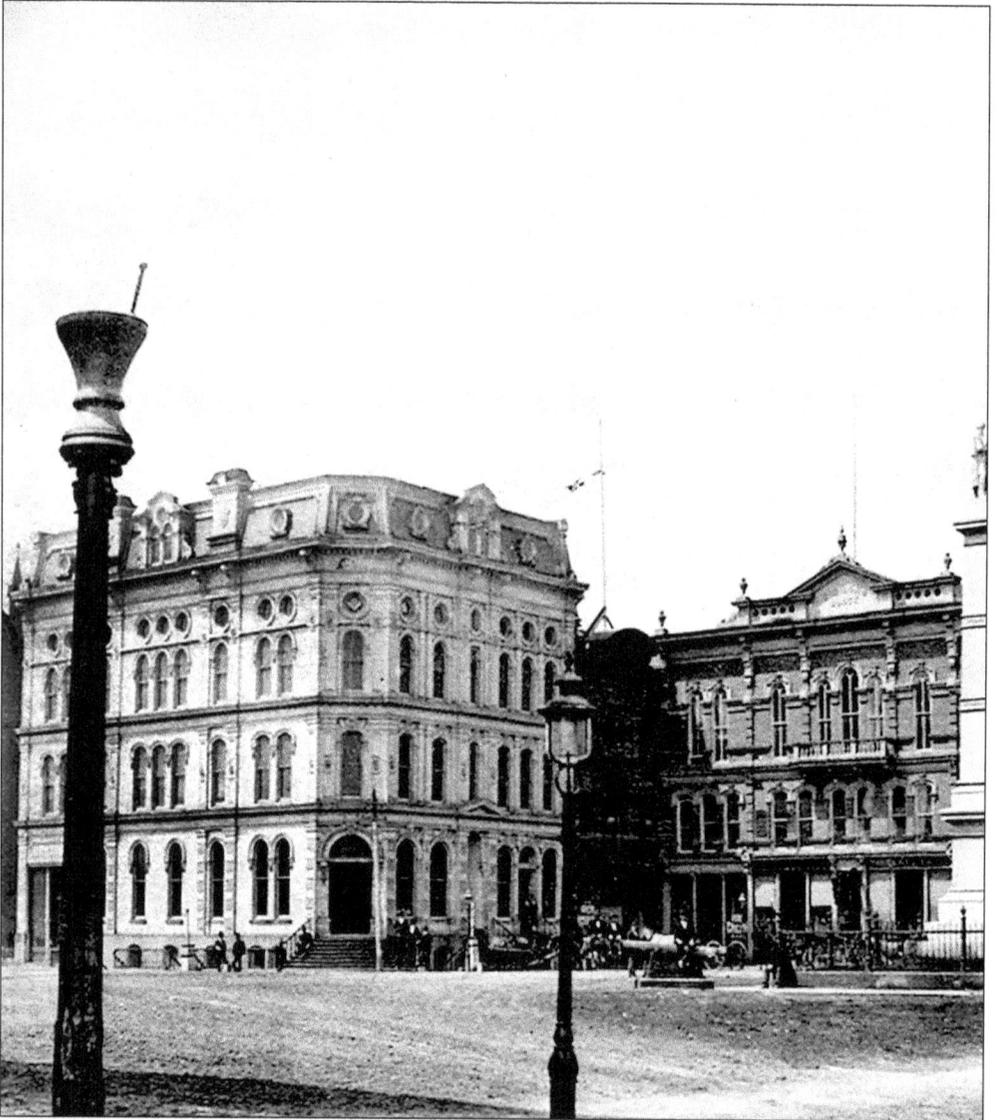

Sunday, March 14, 1909, was a great day for Valley Irish as the AOH opened their new headquarters in the Diamond Block (pictured above, right) that was located next to the Mahoning Bank Building on the "Diamond." Speeches by Father J.I. Moran, State Chaplain and M.J. Barry, State President highlighted the dedication ceremony attended by 300. Mrs. Rose Kennedy and John Buckley performed vocals. (Courtesy of Richard Quinn.)

(*left*) James Quinn served as the president of the Mahoning County Ancient Order of Hibernians (AOH) from 1906–1908 as well as that of Division Five. An activist in politics, government and organized labor, Quinn was the Eighth Ward councilman, director of Youngstown's Department of Public Safety, president of the Association of Sheet and Tin Workers, and served three terms as the president of the Musician's Union. (Courtesy of Richard Quinn.)
(*right*) William P. Kennedy, the great grandfather of Peggy (Kennedy) Holzbach of Canfield, was the 1922 county president and chairman of the AOH Annual Field Meet and Basket Picnic, a combined event hosted by the Valley's Four Divisions. His son, W. Edward Kennedy, was AOH Division Two president. (Courtesy of Peggy Kennedy Holzbach.)

Catherine Ward, the daughter of John F. and Mary Croft Ward, was the 1922 president of Ladies Auxiliary of the AOH. Her "Hibernian" interest came naturally as her father, a native of Waterford, Ireland, served as Division Five president and state vice president. (Courtesy of Sally Quinn Jarvis.)

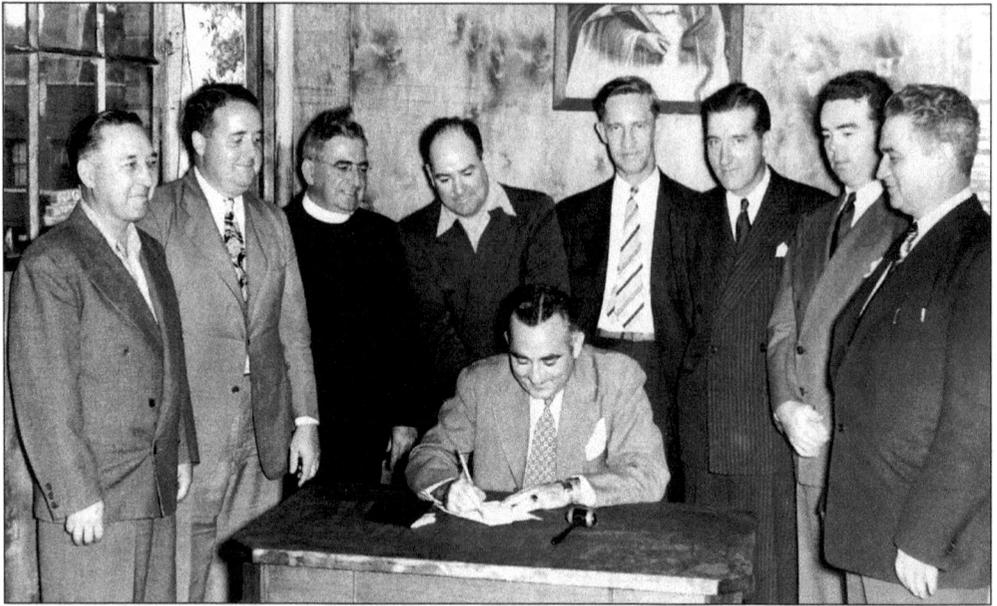

Jack Bannon is pictured signing the first Ancient Order of Hibernians' Charter in 1940 under the watchful eyes of fellow Hibernians. They are: (left to right) Hank Weldon, Judge Donahue, Chaplain Father Calling of Sacred Heart Church, Joe Burns, Ed Toohey Sr., Jack Cox, and two unidentified members. (Courtesy of William Toohey.)

Oistin MacBride (seated in the center), author and photographer of the Irish photograph-biography, *Family, Friends and Neighbors*, is shown with members of Mahoning County AOH, Joseph E. Nalley Division Six, including Mahoning County president and state vice-president Daniel O'Connell (standing, far right middle row). Other Valley Divisions are the Sean MacBride Division No. One of Trumbull (Ohio) and the Sons of Erin Division No. One of Mercer (Pennsylvania) Counties. The AOH is a fraternal organization dedicated to promoting Irish-Catholic brotherhood throughout the world. (Courtesy of Sally Murphy Pallante.)

116

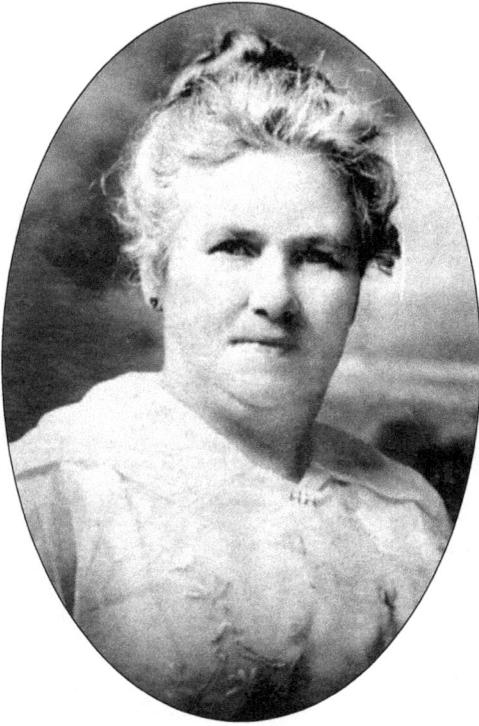

(*left*) Ellen Turly Welsh, an active member and officer of the AOH, was the organizer of the Junior Division, Ladies Auxiliary, and Division One. The duties of the Ladies Auxiliary were shared by Mrs. Julia Downey, Mrs. Ann Carney, and Mrs. Madeline Dugan. These lady Hibernians hosted the *circa* 1944 St. Patrick's Day celebration. (Courtesy of Mrs. Donna Rowan Leone.)

(*right*) Bessie Spangel (seated), and her daughter Joyce Kale Pesta, are active leaders of the Ladies AOH. In 2003, Joyce succeeded Bessie as president of Golden Rose Queen of Ireland, Division Six, a post Spangel had held for 20 years. (Courtesy of the LAOH Historian.)

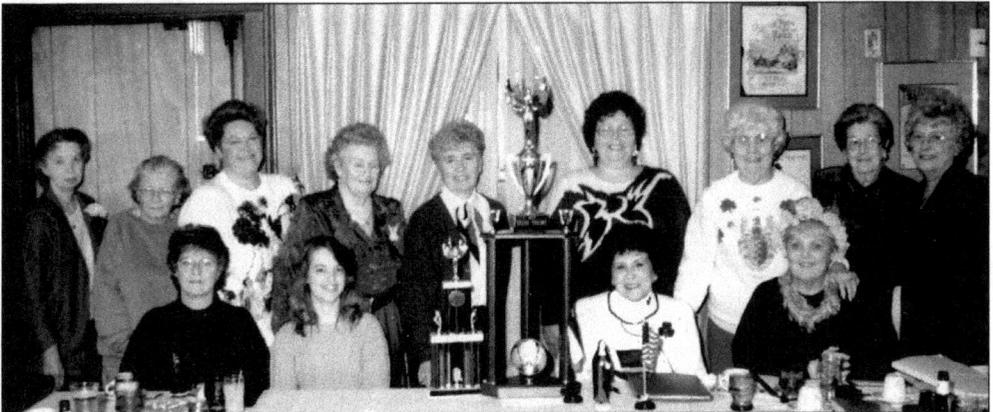

The Ladies AOH celebrates Christmas at a holiday party at the Colonial House *circa* 1995. Mary Kennedy, standing second from the left, was born in Dingle, County Kerry, in 1906 and is still an active member of the Golden Rose, Queen of Ireland Division Six. (Courtesy LAOH Historian.)

The Ladies Ancient Order of Hibernians Golden Rose-Queen of Ireland Millennium Women of the Year Honorees are: (front row, left to right) Dee Cummings, President Bessie Spangel, and Mary Kennedy; and (standing, left to right) Sally Murphy Pallante, Joyce Kale-Pesta, Dorothy McLaughlin, Carol Kelly, Betty Gahagan, Sharon Sabatka, and Peggy O'Neill Lozano. Since 2001, women to receive the honor are Eileen Porter, Catherine Nirschl, Danielle O'Neill, and Mary Ann Tanner. (Photograph by Bob Knuff, used with permission.)

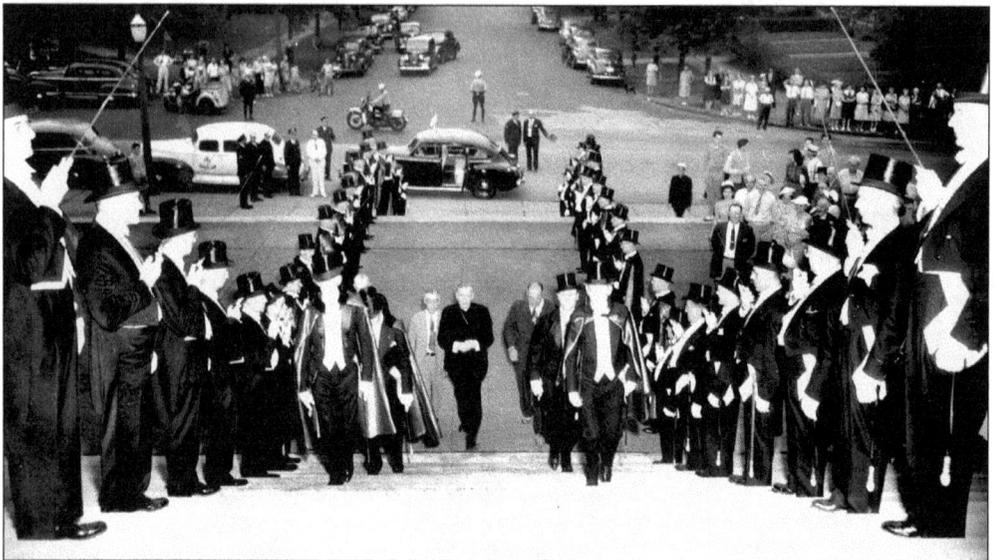

Circa 1943, the Knights of Columbus form an impressive honor guard for Youngstown's newly installed Bishop, James A. McFadden, as he begins to climb the steps leading into Stambaugh Auditorium. Bishop McFadden shared an Irish heritage with Harvey Wiley Corbett, the architect who designed the auditorium that majestically adjoins Wick Park. (Courtesy of the Vindicator Printing Company, copyright 2003.)

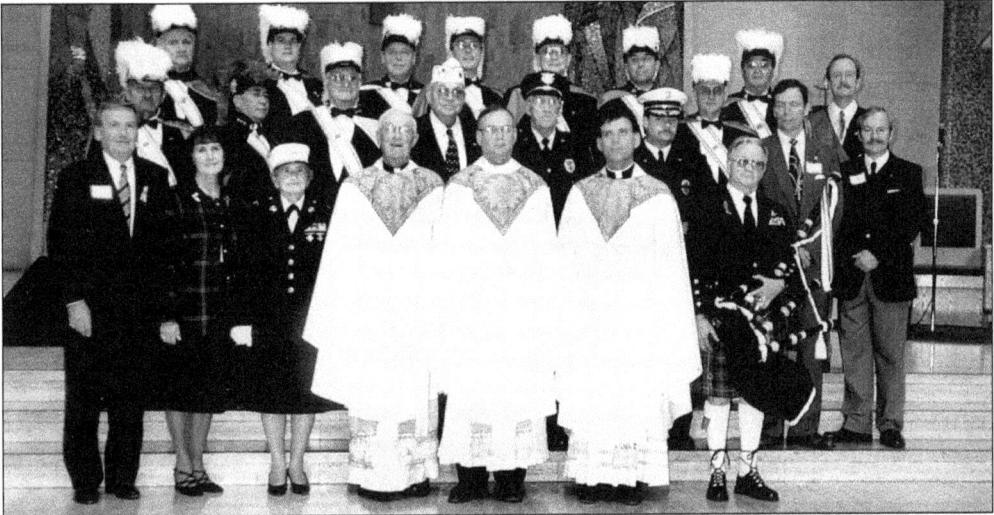

The Gathering of the Irish Clans sponsored a Memorial mass at St. Columba's on Veteran's Day, November 11, 2001, commemorating the two-month anniversary of 9/11. Flanking the three concelebrants, Monsignors Thomas Kelly, Thomas Siffrin, and Father Michael Swierz on the left are Martin Pallante, Irish Archival Society; Sally Pallante, president of the Gathering of the Clans; retired Marine Colonel Josephine Restuccio; and on the right, Piper Norb Moran. In the second row behind the concelebrants are retired USAF Captain Don McClain, Youngstown Police Chief Richard Lewis, and Fire Chief John J. O'Neill Jr., followed by Leo Jay of the Ulster Project and Ted Miller of Muintir na h'Eiréann. Members of the Knights of Columbus Honor Guard flank Joe Casey of Sean MacBride Division of the Trumbull County AOH.

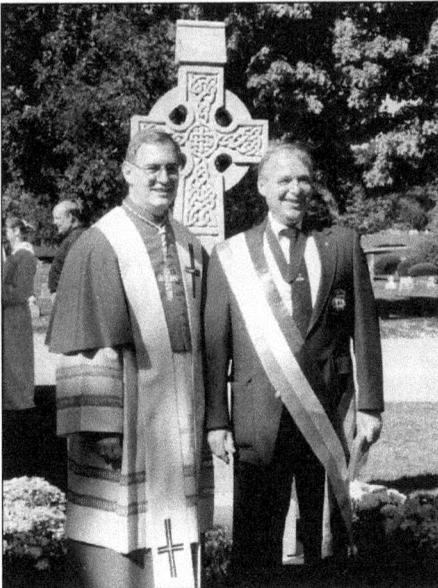

(left) Bishop Thomas Tobin is pictured with Tim Mulholland of the Joseph T. Nalley Division Six of the AOH at the dedication of a Celtic Cross, a Famine Memorial at Calvary Cemetery. (right) Dan Carlon and his wife, Elizabeth, were born in Ireland, he in Kiltemagh, County Mayo, and she in County Monahan. An accomplished accordionist, Don played for Irish weddings and traditional Irish house parties. (Courtesy of Theresa Carlon Murphy Reardon.)

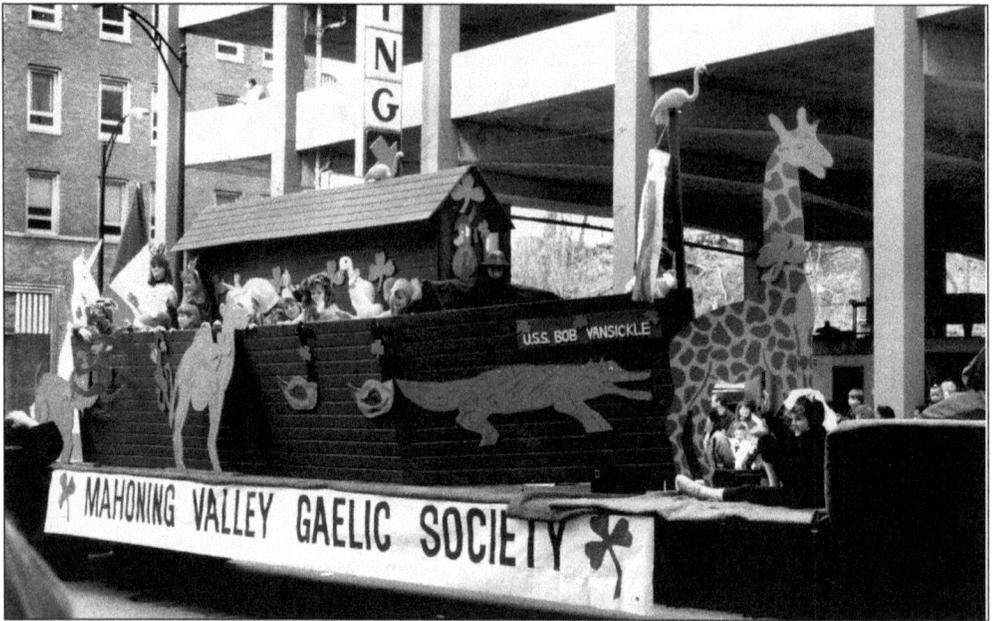

The Mahoning Valley Gaelic Society, whose St. Patrick's Day Parade float is seen above, had its beginnings in early 1960 when a group of about 20 Irish-Catholic men met at Holy Family in Poland. The Gaelic Society functions on five basic principles, the first of which is to promote among its membership knowledge and appreciation of their Irish culture. (Courtesy of Joyce Kale Pesta.)

Members of the Irish Heritage Society carry a "curragh" (Irish fishing boat) in the St. Patrick's Day parade. Pictured, left to right, are: Kevin Hayden, Kevin Hernan, John Hayden (only his feet are shown), Roger Hwenan, Tom Flynn (behind the curragh), Ted Miller, and John Lavelle, who totes the oars. The Irish Heritage Society was a non-sectarian organization of men and women who share an Irish ancestry and appreciation of the heritage and culture. The history, traditions, arts, and humanities of Ireland were presented in programs for their intrinsic value to the members and for an appreciation of the contributions of Ireland and Irish people to world society. (Courtesy of Sally Murphy Pallante.)

Thanks to the Mahoning Valley Ulster Project, annually since 1988, July has been filled with much fun and many learning experiences as friendships are formed between host teens and their families and visiting Northern Ireland teens. The project, which brings together an equal number of Catholic and Protestant boys and girls, is dedicated to breaking down the prejudicial barriers to peace in Northern Ireland by demonstrating that people of different faiths can live together in harmony and actually prosper because of their diversity. Members of the 2000 Mahoning Valley Ulster Project: (first row, left to right) Chris Warden, Roisin O'Brien, Becky Coyne, Bronagh McDonald, Carrie Hubbard, and Kristin Hartz; (second row) Helen Caughey, Leslie Smith, Danielle Pallante, Peter Barr, David Porter, Angelo Martinez, and Ashliegh Roberts; (third row) Gemma McMaster, Joanne Hutton, Dana Chauvin, Mike Hartz, Breanna Jay, Edward Henderson, and Frances Skelly; and (fourth row) Paul Reynolds, Matt Merritt, Philip Hahner, Christopher Brunt, Brendon McGourty, Seth Warden, Joseph Wilkinson, and Stewart Drennan. (Courtesy of Danielle Pallante.)

The strength of the bonds that have been formed are readily seen in this photograph as the 1997 Northern Ireland teens depart on their journey home. Teens standing at the bus are, left to right: Stacy Griffin, Megan Merritt, Katie Curran, K.C. Kerrigan, Carly Jane and Rena Rink. (Courtesy of Sally Murphy Pallante.)

The Irish American Archival Society was founded in 1986 with a mission to collect, present, and preserve the photographs, records, oral histories, and memorabilia of area Irish. Jim Dunn and an unidentified YSU volunteer are pictured in the Ireland tent at the annual Festival of Nations held at Youngstown State University. On the right, Rick Richie and Eleanor Carney stand next to the IAAS banner selling Irish scones. The IAAS, author of this book, has donated two Irish cultural suitcases to local arts councils that are available to Valley schools studying Irish Heritage. (Courtesy of IAAS.)

Bessie Spangel organized the Ladies AOH Juniors' Division Six in 1992. Shown singing "Our Lady of Knock" at the 2000 Gathering of the Irish Clans' opening mass are: (front row, left to right) Kara Loomis and Kelly Kratofil; (back row) unidentified, Erin Loomis, Colleen Kratofil, Lauren Kepley, Ashley Kale, and Rachel Kepley. (Courtesy of Joyce Kale Pesta.)

The Gathering of the Irish Clans, a cooperative effort of local Irish organizations, has become one of the highlights of the Greater Mahoning Valley's summer scene. Traditionally, this family day of Irish heritage appreciation begins with mass celebrated by Galway's own Monsignor Thomas Kelly and features the best of Irish music and dance, vendors selling a wide array of Irish merchandise, the Land of the Little Leprechauns, and tempting Irish food and beverages. (Courtesy of Sally Murphy Pallante.)

Those attending the 2003 Gathering mass pay rapt attention as Monsignor Thomas Kelly carefully explains each of the offerings presented to him during the Presentation of the Gifts. The Gathering of the Clans is a family event, and it is common to see three generations enjoying and celebrating their heritage together. (Courtesy of Sally Murphy Pallante.)

The Irish National Caucus, a U.S. organization dedicated to human rights, justice, and peace in Ireland, was very visible in the Valley in the late 1970s and early 1980s. Taken of a local meeting at the Youngstown Elks Club, this image shows Paddy Maloney and Regis Reddington immediately to the left of Father Seam McManus, national director. Tom Thornton and Steve Molloy are first and second in the back, Harp Lyden is immediately between Reddington and McManus, while Terry Joyce is at the far left of the director. Unidentified gentlemen in the picture are from Cleveland. (Text courtesy of John "Harp" Lyden, photograph by Thomas Thornton.)

Regis Reddington, an active supporter of the Irish organizations and Catholic schools, helped organized the Alumni Office at Ursuline High School after retiring from a senior management position with the *Exponent* in 1980. The *Ursuline Quarterly* and Irish Show are also among his passions. For all of his 93 years Reddington has believed in work over rhetoric and to this day lives by the creed that "I shall grow old someday perhaps, but not today." (Courtesy of Ursuline High School.)

William G. "Bill" Lyden, the late CEO and Chairman of the Lyden Company was proud of his Irish heritage. He was a member of the group instrumental in establishing "The Night of Irish Stars" benefit Irish Show in 1976 and assumed the chairmanship when the Ursuline Alumni and Friends took responsibility for the show in 1982. Together with Regis Reddington, Lyden annually brought world class Irish entertainment to Powers Auditorium. (Courtesy of Ursuline High School and Regis Reddington.)

Dan Gallagher, left, with Irish Show headliner John McNally after the 1990 show. Gallagher, a longtime supporter of all things Irish, became producer of the Irish Show in 1989 and together with Bill Lyden continued the tradition of bringing the best in Irish song and dance to enthusiastic, sold out audiences. Regis Reddington wrote that the "show was a social event; a once a year get together to exchange pleasantries, just like an Irish wake." (Courtesy of Ursuline High School and Regis Reddington.)

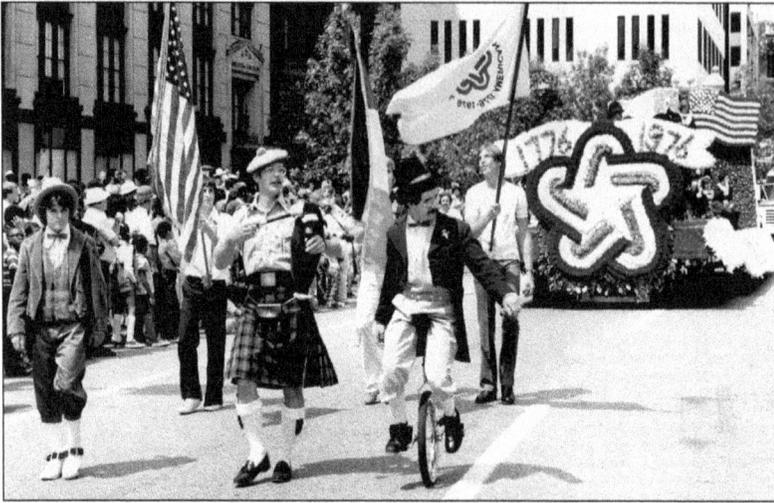

Chairman of the 1976 Irish Float Project for Youngstown's Bicentennial Parade, John R. Reddington, praised the 14 hard working committee members of the Irish community who combined resources to create a spectacular float with 6,800 fresh carnations and Irish presence. Receiving special commendations were Ken McMahon, Dan and Richard O'Horo, Robert Hanahan, Midge Crishal Welsh, Tom Barrett, and Tim Mulholland. Standing atop the float were costumed representations of Irish-American contributors to American greatness. Identified in front of the float is unicycle rider Joe Sullivan, a graduate of the Barnum and Bailey Clown College. (Courtesy of John Regis Reddington.)

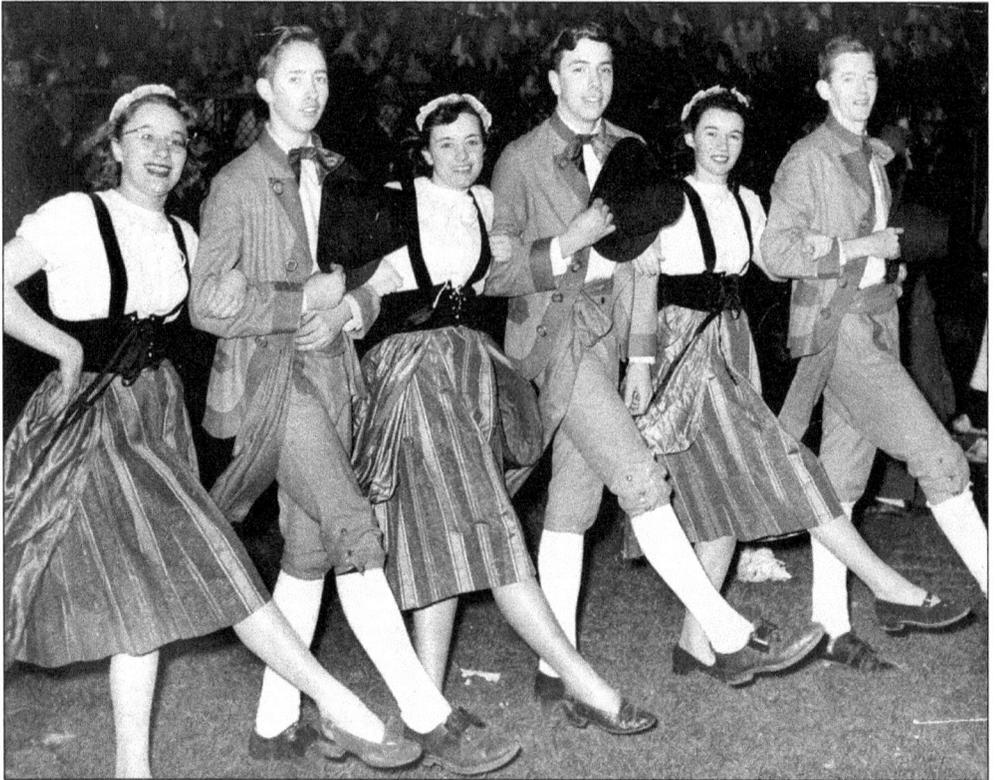

This photograph of a 1948 Ursuline halftime performance shows from left to right: Nancy Joneas, Reverend Frank "Skip" Lehnerd, Nancy Tinkler Michaels, Victor Shutrump, Jenny Franklin, and Joe Koken doing the Irish jig. (Courtesy of Nancy Michaels.)

The fourth-grade class of St. Christine School is seen at St. Columba Cathedral participating in the annual St. Patrick's Day mass sponsored by the AOH and the Ladies AOH. Virginia Collins and her daughter, Maureen have been the vocalists and provided the music for this mass for 25 years. (Courtesy of Mrs. Palkovic, St Christine's.)

St. Christine's fourth-grade class prepares to enter St. Patrick's Church for the 2003 AOH/LAOH St. Patrick's Day mass. The St. Christine fourth grade has a long tradition of participation in the annual March 17th liturgy: (front row, left to right) are Colleen Sturgeon, Marc Ruse, Danny Reese, and Katie Woodford. (Courtesy of Mrs. Ruse.)

Monsignor Kelly, pastor emeritus of St. Christine's, is seen celebrating the 2003 St. Patrick's Day mass. Jason Olesh and Jason Hradil are the servers on his left and right respectively. Each year, the AOH/LAOH Man and Woman of the Year attend this mass and are honored at the following luncheon. (Courtesy of Mrs. Ruse, St. Christine's.)

ℬIBLIOGRAPHY

The following sources were essential in preparing the captions and introductions for this work and are recommended reading for more information on the Irish in the Mahoning Valley.

Blue, Frederick J., William D. Jenkins, H. William Lawson, and Joan M. Reedy. *Mahoning Memories: A History of Youngstown and Mahoning County*. Virginia Beach, Va.: The Donning Company Publishers, 1995.

Butler, Joseph G. Jr. *History of Youngstown and the Mahoning Valley Ohio*. 3 vols. Chicago: American Historical Society, 1921.

————. *Recollections of Men and Events: An Autobiography of Joseph G. Butler*. New York: G.P. Putnam's Sons, 1927.

Callahan, Nelson. "History of the Irish in the Mahoning Valley," lecture delivered at the International Institute at Youngstown State University, 15 March 1981.

The Catholic Exponent.

DeBlasio, Donna M. *Youngstown: Postcards from the Steel City*. Chicago: Arcadia Publishing, 2003.

Diner, Hasia. *Erin's Daughters in America: Irish Immigrant Women in the Nineteenth Century*. Baltimore: Johns Hopkins University Press, 1983.

Griffin, William D. *The Book of Irish Americans*. New York: Times Books, Random House, 1990.

Hamilton, Albert. *The Catholic Journey Through Ohio*. Columbus: Catholic Conference of Ohio/Abbey Press, 1976.

Hernan, Maribeth Burke. *A Circle of Caring: The Story of St. Elizabeth Hospital Medical Center*. Youngstown, Ohio: St. Elizabeth Hospital Medical Center, 1986.

Knepper, George. *Ohio and Its People*. Kent, Ohio: Kent State University Press, 1989.

McFadden, James. *The March of the Eucharist*. Youngstown, Ohio: Diocese of Youngstown, 1951.

McGovern, Michael. *Labor Lyrics and Other Poems*. Youngstown, Ohio: Vindicator Press, 1899.

Pearce, Mallory. *Celtic Frames and Borders*. Mineola, N.Y.: Dover Publications, Inc., 1998.

————. *Ready to Use Decorative Celtic Alphabet*. Mineola, N.Y.: Dover Publications, Inc., 1998.

These Hundred Years: A Chronicle of the Twentieth Century as Recorded in the Pages of the Youngstown Vindicator. Youngstown, Ohio: The Vindicator Printing Company, 2000.

Ursuline Alumni Quarterly.

Ursuline High School Alumni News.

Youngstown Vindicator, 1929–2003.

www.ingramcontent.com/pod-product-compliance
Lightning Source LLC
Chambersburg PA
CBHW050638110426
42813CB00007B/1843